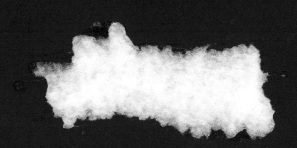

Reconstructions

Dedicated to Sini –
the one who holds it all together,
and to our greatest works so far,
Lumi and Luca.

Reconstructions

'The Troubles' in Photographs and Words

Poems & Words by Steafán Hanvey
Photographs by Bobbie Hanvey

MERRION PRESS

First published in 2019 by
Merrion Press
An imprint of Irish Academic Press
10 George's Street
Newbridge
Co. Kildare
Ireland
www.merrionpress.ie

© Steafán Hanvey & Bobbie Hanvey, 2019
Words © Steafán Hanvey
Photographs © Bobbie Hanvey Photographic Archives, John J. Burns Library, Boston College, Massachusetts
Courtesy of the Trustees of Boston College
Editor: Desmond C. Fitzgibbon

9781785372162 (Cloth)

British Library Cataloguing in Publication Data
An entry can be found on request

Library of Congress Cataloging in Publication Data
An entry can be found on request

Graphic Design: Amanda / Creanda Oy and Steafán Hanvey
Interior design by www.jminfotechindia.com
Typeset in Adobe Garamond Pro 11.5/15

Jacket front: PIRA Bomb in Belfast city centre. Bobbie Hanvey Photographic Archives (MS2001.039),
John J. Burns Library, Boston College.
Jacket back: RUC officers from Clogher station with Sarah Primrose.
Photographic title: bh012536
Bobbie Hanvey Photographic Archives (MS2001.039), John J. Burns Library, Boston College.

Contents

ADVANCE PRAISE FOR *RECONSTRUCTIONS*

'*Reconstructions* is a wondrous outburst. Steafán Hanvey's poems are an unrestrained response to the work of his father, the great Irish photographer Bobbie Hanvey. They are bold improvisations on his themes of conflict and community. These heartfelt refractions find their own shape. They are nobly dishevelled, and they cry out to be read.'

Michael Longley

'This unique and heady blend of documented violence and photographic memory poses timely questions for present social understanding of the way we were. [Its] drama and tragicomic wit ... is both potent and devastating'

Medbh McGuckian

'Authentic, innovative and keenly honed prose poetry ... An astonishing and visceral work that strikes clean to the often-dark but always-shining heart of Northern Ireland. A heady combination of words that set the pictures alight.'

Billy O'Callaghan

'Steafán Hanvey was eyewitness to the genesis of so many of his father's famous photographs, and it is obvious that the father's iconic work has lain in the darkroom of the son's memory and imagination, waiting to be developed into prose-poems of poignancy and power, showcased now in *Reconstructions*, a stunning symbiosis of word and image.'

Adrian Rice

We did not write in Yeats's shadow, as some would have it, but in the lighthouse beam of his huge accomplishment.

–Michael Longley

Acknowledgements

This book's making wasn't entirely of my own doing – far from it. My darling Sini must take the lion's share of the credit for ensuring I got this book over the line. Thanks for putting up with me and for all the heavy lifting over this past few months. I love you.

Thanks to my English teachers in school – Mrs Tumelty, Mr Ritchie and Ms Kelly – for developing my love of the language, encouraging me, and believing in my potential. Ms Kelly said I could be a writer but that I'd need a good editor. Luckily, I found one in Des Fitzgibbon, who acted as my touchstone and whetstone throughout.

Thanks also to Katherine Fox and Christian Dupont at Boston College for granting permission to use my father's photographs for this book. I'm also grateful to Catherine Giltrap at Trinity College Dublin, for her help, support and friendship.

Thanks to my da for getting the photographs print-ready for this book, and for all the encouragement and positive feedback along the way.

Thanks to my mother for instilling in me a love of books from an early age, and for encouraging the university route. I still remember the day you took me down to join Downpatrick library and to buy my first books at the Music and Book shop.

Thanks to Seppo Vehviläinen for help with my old back and for the use of your summer cabin.

Thanks to Billy O'Callaghan, one of my favourite writers, for your endorsement in the Foreword. It means the world to me.

Thanks to Medbh McGuckian, Michael Longley and Adrian Rice for sharing your thoughts on the book. This was unexpected and immense.

Thanks to Dearbhaile Curran for taking the time to proof much of the manuscript.

Finally, thanks to Conor Graham at Merrion Press for seeing the potential in the book from early on, and for offering me the launching pad for my poems.

Foreword

Billy O'Callaghan

Author of *The Dead House*, and *The Things We Lose, the Things We Leave Behind and Other Stories*.

Steafán Hanvey must rank as one of Ireland's best-kept secrets – poet, film-maker and singer-songwriter of the first order, a striking and unique talent ripe with the experience of a hundred lives lived and a thousand more observed. For the past several years, he has toured the world with a highly acclaimed multimedia performance incorporating songs, spoken word and projections from his father's vast collection.

World-renowned photographer Bobbie Hanvey was the eye that captured forever, in all their unflinching glory, some of Northern Ireland's most defining moments. Now, set in context by some of Steafán's most authentic, innovative and keenly honed prose poetry, these images take on even greater resonance. The result is an astonishing and visceral work that strikes clean to the often dark but always shining heart of Northern Ireland during its most troubled decades. It makes for the purest and highest art, a heady combination of words that set the pictures alight and pictures that tell a thousand stories, spanning the entire scale between black and white, infusing the devastation and trauma of their subject matter with the strength, determination, courage and hope that defines, as only the finest art can, a place and its people. *Reconstructions* is a celebration of life and a validation of two lives' work.

Introduction

A few years back, my father emailed me a black-and-white photograph of Main Street in Brookeborough, his home village in Co. Fermanagh. I used to spend my Easter holidays and some of my summer holidays down at my Granny Hanvey's in the same village. She would often mistakenly refer to me as 'Bobbie' – my father's name – to which I passed little heed. I never let on, for I knew, even as a child, that she'd just mixed us up, and to put her right, I thought, would have embarrassed us both no end. So, I just went by 'Bobbie' when I was staying with her. To the local kids, I was known as 'Hansy's cub'. To complicate matters even further, when I saw photos of my da as a child, I thought they were of me; so much so, that I wouldn't believe my parents or my granny when they tried to convince me otherwise. This close resemblance made more sense of my granny's mix-up. To her, having me around, was like having her Bobbie back. It was clear she missed him terribly and that she was very lonely, having become a widow several years earlier. So, I was really company for her in her later years, something I'm glad of when I look back.

Getting back to the photograph of Brookeborough: no sooner had I received it than I had written a poem about my stays with Granny Hanvey. Within twenty minutes, I'd sent it back to my father. I was aware that I had a collection of memories that would have been very similar to his own as a child. Perhaps I was trying to impress upon him our shared experience. Happily, he reacted positively and the idea for this book was born.

Having just one month earlier become a father myself for the first time, I was enjoying a breather from a prolonged period of touring my second album *Nuclear Family* and its artistic corollary, a multimedia performance called *Look Behind You!™ A Father and Son's Impressions of the Troubles through Photograph and Song*, which happily brought my father's work to new and distant audiences.

Curating, producing and eventually touring *Look Behind You!™* had shown me that I had several channels of expression before me. Things were opening up, even if

words were still the primary focus. Quite surprised at how easily the memories made their way down the pen and onto the page, I thought it would be an interesting and challenging project to embark upon, so I got writing. Although I had been working with words in one form or another for most of my life, this experiment and process proved to be a different animal altogether – different to anything I had previously tried or produced. I then started to revisit some of my father's iconic photographs with the intention of producing a poem for each. In the end, the photos were part-inspiration, part-confirmation, in that I reacted to some and wrote new poems, whereas others complemented pieces I'd written at earlier stages of my life.

Growing up in the house anomaly built meant that I was present at the conception of many of these photographs. I witnessed their act of becoming, as it were, and marvelled as they developed a life of their own in chemical trays. I pegged many of them on the drying-line myself and often had a hand in the framing before they took up residency on the walls of our home.

Sometimes, after having been out in the wee hours on the latest adventure, I'd put the photographs on the day's first buses to their pre-arranged collection point, ready for whatever newspapers happened to be carrying them that day. I watched them take on other lives too – on book covers, inside the books themselves, and on record covers. I witnessed and partook in captions in the making, photographs of me and us all in the taking.

My point is, they were there as much for me growing up as I was for them and now that they've found a new virtual home in an archive in Boston Mass., I thought I'd take a torchlight and blow a layer of dust off and say to the world, 'Look, over here! This is something to see!' And look they did, and they're still looking.

We all look at photographs differently; we see new things every time we revisit them, details we may have missed first time around, which I suppose is why we have the phrase 'one look is worth a thousand words'.

It's clear who pressed the button. My father has likened the capture itself to a sniper pulling a trigger: 'You look through the camera the same way a sniper looks through a gun. You press the shutter, he presses the trigger. He hopes to get something. I don't think there's much else

involved.' He conceived these photographs and I hope that my words, responses and memories do them and their taker – my *fathographer* – the justice they deserve. I also hope that in my presentation of each reconstruction that I have afforded the less-fortunate – those who lost their lives, and those who were hurt and are hurting still – their due respect.

This is my first collection of poems.

Steafán Hanvey, 2018

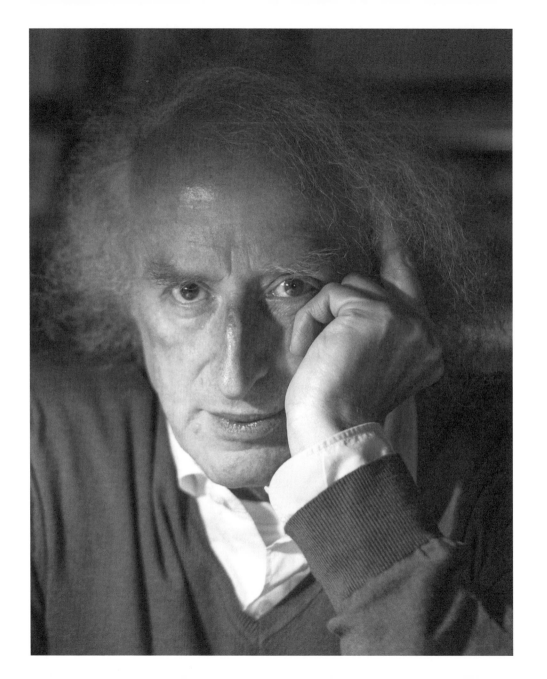

BIOGRAPHIES

Bobbie Hanvey (The Father)

Bobbie was born in Brookeborough, Co. Fermanagh, in 1945. During the early years of the Troubles in the late 1960s and early 1970s, he worked as a psychiatric nurse. However, he chose to leave the hospital to minister to the wider community by documenting the madness all around him with his camera and microphone. (Given the Troubles, and that George Bernard Shaw claimed that 'Ireland was the largest open-air lunatic asylum in the World', this move seemed to make sense!) Bobbie was an ardent campaigner for civil rights in the late 1960s and early 1970s.

The Troubles presented Bobbie with an opportunity. By photographing the eerie aftermath of bombsites and shootings, he was able to provide for his family while also becoming known as one of the country's leading press and portrait photographers. In 1985, 1986 and 1987, he won the Northern Ireland Provincial Press Photographer of the Year Award, and in 1985 and 1987 he also won the Northern Ireland overall award for Best People Picture. These were the only three years that he entered the competitions.

Bobbie has also published two collections of photographs: *Merely Players: Portraits from Northern Ireland* (1999), which presents portraits taken since the 1970s of poets, playwrights, paramilitaries, priests and politicians. They include Brian Friel, Seamus Heaney, Danny Morrison, David Hammond, Gerry Adams, Sammy Duddy and others.

His most recent photographic book, *The Last Days of the R.U.C, First Days of the P.S.N.I* (2005), presents the only historic account of the transition of the Royal Ulster

Constabulary to the Police Service of Northern Ireland. His book, *The Mental* (1996), is an account of his early days spent as a psychiatric nurse at The Downshire Hospital in Downpatrick.

Bobbie also hosted a programme on Downtown Radio called *The Ramblin' Man* for thirty-six years, where he interviewed over 1,000 people of all shades of persuasion throughout and after the Troubles. Guests on his programme included Ulster Volunteer Force leader Gusty Spence, Provisional Irish Republican Army veteran Joe Cahill, the last four Chief Constables of the Royal Ulster Constabulary (RUC) and its successor organisation, the Police Service of Northern Ireland, John Hermon, Hugh Annesley, Ronnie Flanagan and Hugh Orde. Other guests included writers Eugene McCabe, Maurice Leitch and J.P. Donleavy, as well as soldiers, sailors and Travellers.

Bobbie's photographs have appeared in *Paris Vogue*, *The Village Voice*, *The Melbourne Age*, *The Irish Times*, *The Economist* and *NPR*. He wrote a weekly column for *The Belfast Newsletter*, Ireland's oldest newspaper. Still active as a photographer, only recently going 'electric' (digital!), his unique collection of photographs is to be found in the Burns Library, Boston College, Massachusetts.

An interesting footnote to this fact is that Fr. McElroy, S.J., a Jesuit priest and, like Bobbie, a Brookeborough man, was one of the original founders of Boston College, Mass., back in 1863; quite a fitting coincidence, given that Bobbie's body of work would find a home in its archives.

Bobbie currently lives in Downpatrick, Co. Down.

'When I first stumbled across the photographs of
Bobbie Hanvey, I thought I had found an undiscovered
master — perhaps another sort of Vivian Maier.
Arguably, Hanvey's photographic work rivals that of great
American photographers such as Walker Evans,
Dorothea Lange, and even the spot news artist, Weegee.'

–NPR

'Bobbie Hanvey is extraordinarily talented.
He just has an insatiable appetite for photographing.'

–Dr Robert O'Neill, Burns librarian at Boston College.

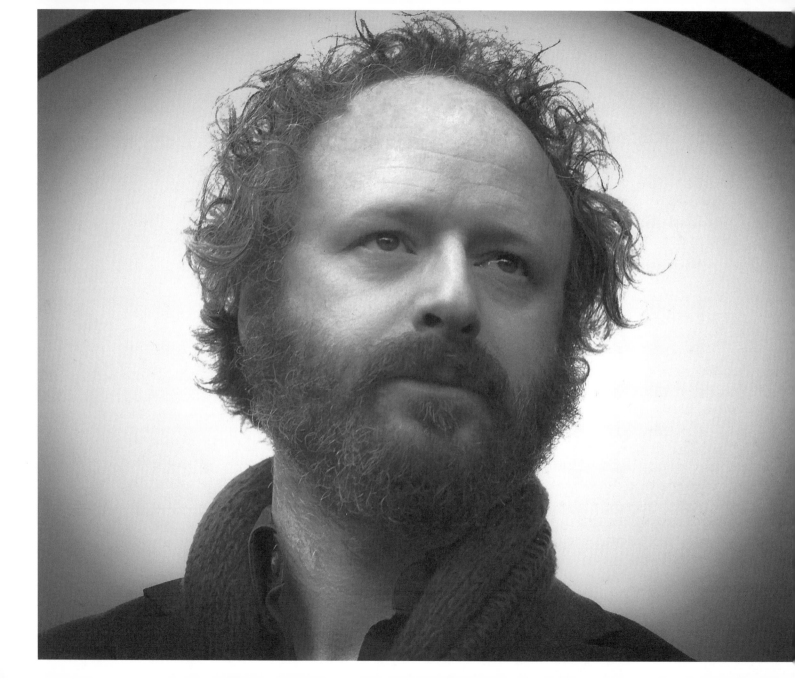

Steafán Hanvey (The Son)

Steafán was born in Downpatrick, Co. Down, in 1972, five months after Bloody Sunday and one month before Bloody Friday. His exposure to all things musical began *in utero* as he is the son of musicians. In the 1970s, his household was renowned for its traditional 'sessions'. Still in short trousers, Steafán was often called upon to regale guests with a rendition of 'Will You Go, Lassie Go', 'The Cobbler' and 'Carrickfergus'. On his mother's side of the family, he has recently discovered a lineage back to the Brontë sisters. His teenage years were spent fronting rock bands, one of which was an earlier incarnation of Relish, which showcased for CBS Records no fewer than three times.

Steafán graduated from the University of Ulster in 1995 with a Bachelor's degree in Literature and Politics, majoring in American Studies. He spent the third year of his degree studying sound-engineering and American literature as an exchange-student at Western Washington University. Upon his return, he covered the IRA ceasefire in 1994 as a sound engineer for Macmillan Media in Belfast, before pursuing a Master's in International Politics at the University of Helsinki, where his thesis dealt with a comparative analysis of Ireland and Finland's neutrality policies. While in Finland, he gave courses in Irish film and conflict resolution at his *alma mater*, contributed to a government-sponsored Immigrant Musician Workshop at Sibelius Academy, hosted an Irish music radio show, and sang in two Irish/Finnish folk groups. This led in 2000 to a solo EP recording of his original compositions. In short, he was back to his first love.

By special invitation, Steafán performed to a private audience at Dublin's Focus Theatre, the closing of which was formally presided over by the Irish President, Michael D. Higgins. Steafán has shared the stage with Liam Ó Maonlaí & The Hothouse Flowers in the US, Ireland and Spain, and many other acclaimed Irish artists including Relish, Jack L, Maria Doyle Kennedy, Mary Coughlan, Don Baker, The Walls and John Spillane. His critically-acclaimed debut *Steafán Hanvey and The*

Honeymoon Junkies was released in Finland in 2005, Ireland in 2006 and the US in 2011. National television and radio appearances followed, as did several in-studio sessions with BBC Radio Ulster, NPR and others. *Hot Press* magazine called his debut 'a rare delight!' and opined that it was of an 'impressive quality'. Gerry Anderson of the BBC remarked that 'Steafán has earned his place at the table.'

In 2013, he released his second studio album, *Nuclear Family*, in North America through eOne Distribution, a record that had been mixed by Franz Ferdinand and The Cardigans' producer, Tore Johansson. *Nuclear Family* features several guest appearances including Relish and Liam Ó Maonlaí (Hothouse Flowers), and was mastered in London by Mandy Parnell, who has also worked on albums for Feist, John Martyn and Björk.

In addition to producing two albums and a mini-album, Steafán has co-produced, curated, directed and toured a multimedia show in over twenty states of America. This was the platform from which he started introducing his poetry to new ears. Partly funded by The Arts Council of Northern Ireland, and his most ambitious production to date, *Look Behind You! A Father and Son's Impressions of The Troubles Through Photograph and Song* was hailed by the New York *Irish Voice* as 'truly groundbreaking'. They also said *Nuclear Family* was 'brilliant!' NPR took note and produced a short documentary about *Look Behind You!*

Steafán has produced three music videos, one of which, *Secrets and Lies*, was selected for the *kinolounge* special program of the 22nd Sao Paulo International Short Film Festival. In 2016, he was invited to tour the university circuit in Scandinavia by The Irish Itinerary and The European Federation of Associations and Centres of Irish Studies. Steafán has since begun work on his third studio album and is also working on his first feature-length documentary film. He lives in Helsinki with his girlfriend, Sini, and their two children, Lumi and Luca.

22

Steafán Hanvey is thoughtful, intelligent and reflective about the culture and family that shaped him, as well as how it has influenced and defined his recent album, *Nuclear Family*. When I first learned about Steafán and Bobbie Hanvey, I knew their story was something special. One that deserved to be told through the very art that it had inspired.

–NPR

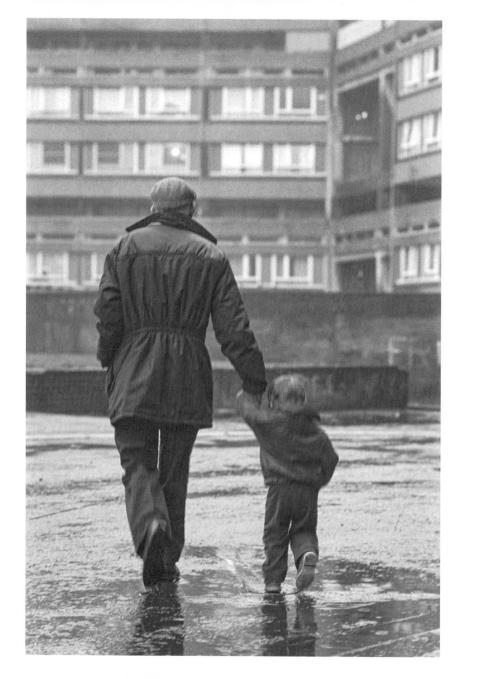

Late Developer

My first lessons in light
were under the cover
of darkness.

From bardic lamp-lit
country roads
to safelight enclosed,
the darkroom in Irish Street
was like a look-out post,
the milk crate –
a bosun-chair,
allowing me,
surgeon's mate,
a child's-eye view
of jackdaws
squatting murderously
on derelict chimneypots,
and of-a-world,
none too fair
or familiar.

Like a surgeon-*cum*-midwife
with suspect-devices,
you took your work
under the knife
in here,
attempting sutures
of out there.

Eager to please,
I'd scan our theatre
through your fag-fug
and mouth a silent
Check! for each tool laid down,
each procedure enacted:
Stop-bath, tongs, developer,
fixer, enlarger, timer,
thermometer, trays, squeegee – *Check!*

With your inverted-subverted images,
you conjured the lifeless,

summoning visions,
bent on renewal.
As the news was breaking
out there,
the water broke in here,
like amniotic fluid
gushing around the sink,
making it difficult
to think.
Like a tilt-shifted
Niagara Falls,
it swished, sputtered,
ebbed and flowed.

You'd let me tip away
at the developing-tray
as we'd impatiently watch
the edges burn grey,
one sorrowful flowering
after another,
secrets wrung from
tragedy, unwriting white,
developing and fixing the night.

Surfacing through
the fog-salt,
negatively positive
stills are born,
light-insensitive,
so peaceful and mute,
rendered, not sundered,
after the storm.

As you pull on your fag
the end flits freely,
firefly-like.
My da:
a memory-making middleman,
assessor from The Ministry of Lost Causes,
taking sides under cover of darkness,
an *aftermathematician*,
reducing a formula,
a variable bidder
with oblivion,
a framer and custodian
of unsolicited closures.
You print contact-sheets
that electrify the eye;
You deliver stills that are

memorial-machines
which incubate
as the world outside
contemplates.

When I spy with my child's eye,
I'm conspiring in
your world of creation.
You're there with the look of
a hunted light-gatherer.

Your *camera obscura*
captures history *in utero*
and performs a routine-delivery.
Yours is a mid-wife's elation,
quiet and jaded,
clutching the slippery spoils of a war
that is long-past born
but labouring still.

Your magical contraption:
full to the brim
with the defaced lore
of places and faces,
times and crimes,
an antiquary of intrigue,
housing a poor man's *chiaroscuro*.

A moment stretched
for partners-in-time,
we're the aproned saints
of impossible causes –
late developers.

Behind the Lens
and
Between the Lines

Late Developer

When I was in America touring *Look Behind You!* and *Nuclear Family*, a lady approached me one night and asked if the photograph of the father holding the boy's hand was me and my Da, and when I said it wasn't, she – without missing a beat – replied: 'Well honey, you're in America now, so from now on, that's you and your father!'

The man and child in the photograph are walking through the notorious Divis Flats complex in Belfast. In this instance, the poem was written first and the photograph curated as an accompaniment. I like the symmetry of the subjects' stride, and how their intimacy contrasts with the implacable, modernist facade of the flats and the dark concrete walls. That splash made by the child also appeals to me, as no matter what's going on around you in the adult world, puddles are still for splashing. I also like how the boy – like all kids holding a parent's hand – seems to be lagging behind, scurrying, caught between the need to keep up and the need to do childish things.

The poem was inspired by nights spent watching my father work under the red light, particularly when we lived in Irish Street, Downpatrick, where I spent the first nine years of my life. I can still smell the strangely comforting yet pungent combination of cigarette smoke and chemicals. These days, he develops mostly in *Lightroom*, the photo-developing software. Darkroom during The Troubles, *Lightroom* in times of peace. Fitting.

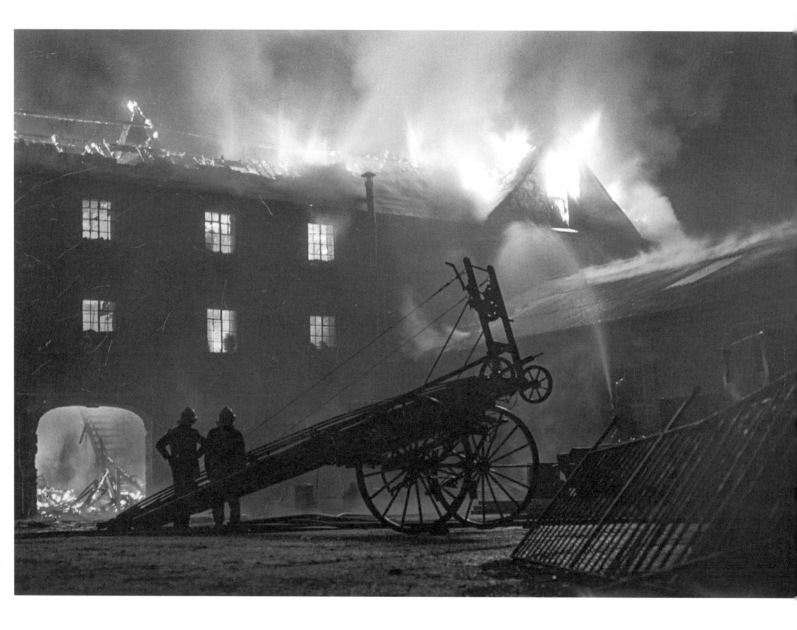

All Key-Holders Attend … (The Devil's in the Retail)

No sound needed to hear this one:
Hugh J. O'Boyle's hardware store is roaring
like a Titanic furnace, going up,
just like t'other went down.
Both would only shine bright the once,
and the very thing that did for the ship
was exactly what these firemen could have done with
on this night to remember.

It's Downpatrick, 1975, and this evening's
devil-cast is coming to us live from up there
where Irish Street meets its false summit,
the Folly Lane, just in there on the right,
before giving way to Stream Street.
Before us stands a business on its last legs:
Mid-*encore*, whipping up a storm,
it's an all-singeing,
all-dancing flames performance,
awash with pyrotechnics
and musical accompaniment courtesy of
The Ulster Cacophonic Orchestra,

Conductor: Old Nick himself.
The fourth wall is about to be broken
but the audience – no longer able to suspend
its disbelief – is ill-prepared.
The *finale*, when it comes,
will bring the house down,
confounding the critics once again
while giving encouragement
to dire authors and their impresarios.

As a young pup,
filled with a shameful giddy-delight,
I used to ride shotgun
to such fires with my Da.
Often arriving before the tenders,
we got to see the firemen
tumble down from their cab
and stand in a hands-on-hips tableau,
allowing themselves to be enthralled,

31

briefly, civilian-like,
by the spectacle before them.
And then how they'd briskly rub their faces
to break the spell, drowning out
all bewitching sounds by shouting
assessments, instructions, and unholy oaths
in accents as thick as any farl
that has ever graced an Ulster fry.
On nights such as these,
The 'Jesus, Mary, and Joseph!' hotline crackled
before going dead.
But most of all, my cheeks remember
the stovish heat, and how my clothes and hair
carried home a thermogenic musk.

Aye, Boyle's was a Roman candle that night.
After all these years,
it still burns bright in black and white.
Hard to believe this was taken in the Seventies –
it looks ancient!
That quaint turntable-ladder is straight
out of the Blitz but …

Aye, ancient, just like the conflict itself
appears to outsiders.
Resembling gawpers at a carny freak-show,
I imagine them holding hands up at temples
like blinkers,
mimicking the combatants' tunnel-vision
as they squint in at us,
with all of our peculiar,
post-imperial particulars
on gaudy display.

Shutter-speeds paying heed as they transform
ecstatic spark into tracer-like ribbons on a stick,
all skite and bow,
flitting away aimlessly
but as dainty a dance as it might well be,
stood next to the main event,
it's soon revealed for the side-show it is –
mere window-dressing,
as if this behemoth
required fancy frill-making.

That fireman at 3 o'clock
seems to be going through the motions,

not wanting to get caught skiving.
His hose, a mind of its own, is jetting
like an uncorked bottle of champagne
into the flood-lit night sky.
Meanwhile, the old hands at 8 o'clock
know a bad thing when they see it,
and leave well enough alone:
The deal with fate has been done,
and those caught in rapture will live
to fire-fight another day.

My da snaps from a cooler remove,
getting all of it and more,
the *now*, forever caught
in its parched element.

The long and the short of it:
This blazer would not be cowered by mortals;
no intervention, divine or other
would temper or quench this scorcher,
as it made its way through the stuff of life.
Though time itself it would not outwit,
tomorrow would come and this furious fit

would be put in its place,
out-shone by the sun
into a state of ungrace undoing, done –
a dire spectacle, born of tribulation,
petering out in its own ruination.

Hugh J. O'Boyle would be seeking salvation
in the small print of an insurance policy.
The dogs on the street would know
who was responsible but not so much
the names of those who'd lost their livelihoods;
Besides, knowing who, won't undo.

I suppose one builder's loss is another one's gain,
if all being *laissez faire* in love and war,
why would the spoils of war discriminate?

Such fires would spread across the province
for decades to come, *going viral*
before the term was even coined;
Proprietors, key-holders, and brave decent folk
would all too often find themselves
running around in pyjamas and overcoats,
living a nightmare
as they hurled buckets of water

on the bastard-flames of history.
And target selectors?
Well, they'd claim that key-holders
should have known better, in fairness.

One last look before I file it away
with all the others.
What an awesome, awful and awe-inspiring sight!
Who said the night belonged to lovers?

Behind the Lens
and
Between the Lines

6. All Key-Holders Attend (The Devil's in the Retail)

This piece was written to the photograph.

Malicious fire at the business premises of Hugh
J. O'Boyle, a building contractor in Irish Street,
Downpatrick in the early Seventies. Night shots of fire
and fire-fighters using the old turntable.

As a child, this photograph caught my eye, as I had
wanted to be a fireman when I grew up.

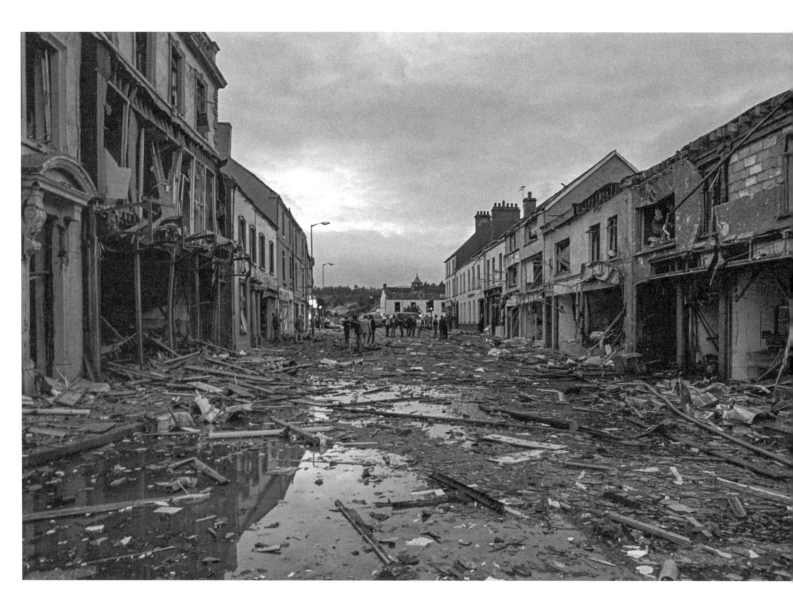

Plan B (Unravelling Night)

Peering down the shaft
of times-past,
I see memories
pulsing in the gloom,
waiting to be re-felt.

Some are the most unreliable of witnesses,
and often the best-forgotten are the least-forgotten,
but still, there they are, and here they come,
re-emerging eternally,
like photographs in a chemical-bath,
developing and re-developing
at their own behest.

And so it was with Plan B,
a prodigal son expecting a welcome –
the worst of bad pennies.

Like all Plan Bs, it lacked the rigour
of thinking through.
Granted, it was equal to its root
in that it all seemed to add up,
but it too counted for naught.

The black theatre of my mind's-eye
presents the freeze-frame stillness,
stop-motion, stopped,
just before the blast-wave jolt,
travelling quicker than sound,
closely followed by
the bolt.

Not from the blue,
but the dark, unravelling night.
Next, the oven-heat,
fevering to the bone,
followed by the back-draft,
sucking life's tit for all it was worth.

And Mother during all this?
Mid-air (forever rising to the occasion!);
It would take more than this
to close her book.

I recall how the heavy, emerald-green
crushed-velvet curtains
bore the brunt and quickly bulged,
as if to prove their true design
as glass-catchers,
before transforming
into titanic bag-pipes
that chimed and squealed
a new music, a reckoning.

Being the eldest at 14,
it fell upon me to check
if the others
were still of this world.

Brother: 12 years old,
a sleeper so heavy
you weighed upon the world –
I found you under the landing-light,

wriggling like an eel in a creel,
gowling from the top-stair of your lungs
in Y-fronts –
proof-enough of your vitality.

Sister: 6 years old,
fast-asleep, all told,
slow to react to my call,
a breathless eternity between shakes,
coming to
only after the third,
your bed shielded
by the thick, resisting gable-wall.

Brushing the broken glass
that lay across your bed,
I exchanged reason for fable,
employing 'Wee Willie Winkie'
to enable your settling:
Tirlin' at the window,
crying through the locks,
are all the childir in their beds,
it's past eight o'clock?

And Father? Camera-clad,
primed for (re)action,
out in the street motor-driving
his way into abstraction,
wise-to-the-world in so many ways,
but knowing little of his universe.

I recall how he regaled us later
with the RUC man's droll:
'Do you believe me now?'
And how he had to climb out
from under the same man,
to find his 'shot'
in a salvo of clicks and whirrs.

Like how the cop saved this family and more
from getting the chop:
As if competing in a diabolical Highland Games,
he had hoisted the suitcase-bomb over a hedge
much taller than himself;
And how this singular act is likely the reason
I continue to draw breath
and have a daughter's hand to hold.

And how I have yet to put pen to paper
to thank him. Where to begin?
Where to begin?

Like how the planters of the bomb
considered themselves true Gaels most likely,
as they drove with Plan A turning in their heads
towards Ballynahinch where the Protestants
beat their drum.
But a police checkpoint put heed to that.
What now? They must have thought.
And looking in the mirror,
they saw Plan B resting with the suitcase on his lap:
Downpatrick? Welshman's?
The off-duty squaddy-bar?
They neither knew nor cared that it was
just two doors from my door
or anyone's door, for that matter.

And it was this back-up to a cock-up,
this contingency for the 'real thing'
that was to crowd my dreaming,
its details compressed into a single moment

where I answered the door
to be greeted by an inferno
of reds and yellows,
and yellows and reds.

After monthly visits for several years,
it ceased stopping with me,
having decided to leave me be.

Behind the Lens
and
Between the Lines

Plan B (Unravelling Night)

On 28 September 1986, the INLA planted a suitcase bomb outside Welshman's bar, an off-duty watering hole frequented by members of the security forces. The pub was two doors from our house in Church Street, Downpatrick. An RUC officer carried the bomb across the road, into an alleyway and over a hedge, where it exploded fifteen minutes later behind a row of terraced houses, opposite ours. The police had knocked on our door a couple of times that week because of bomb scares, all of which had turned out to be hoaxes. On the night of the explosion, my father started to tire of the RUC man's late-night visitations, when suddenly the bomb went off. The bomb had been intended for Ballynahinch, some ten miles up the road, but had been abandoned due to an awaiting RUC roadblock. One of my nine lives was used up that night.

However, the key-holders on Main Street, Ballynahinch, hadn't been so fortunate one year earlier, in 1985, the year the accompanying photograph was taken. No organisation claimed responsibility.

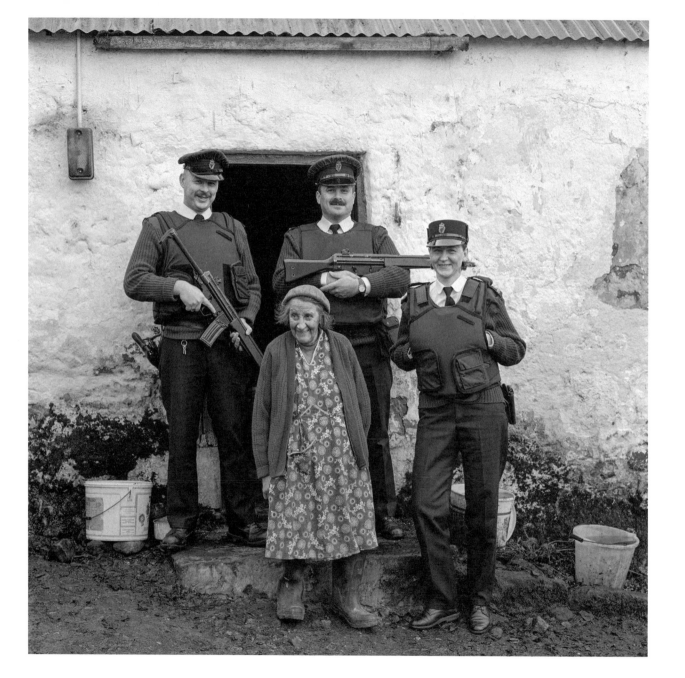

Gotcha!

Cops gate-crashing a period-drama,
three buckets betray her predilection.
If not for the smiles, it could be the Famine:
Headline: 'Defaulter caught mid-eviction.'

Seeing bad in good takes toil and talent.
Lifted for crimes against 'normality',
grossly diligent, dilly-dalliance,
no lime-slaked act goes unpunished, clearly.

As hunters gather, displaying their prey,
too small for her boots, below her station,
pouring her widow's mite into her day.
While *you* frame props and sense of occasion,
prepping whitewash for no one else but her,
the giver of perpetual succour.

Behind the Lens
and
Between the Lines

Gotcha!

This sonnet was written to the photograph.

The lady in the photograph is Sarah Primrose, 'caught' posing with an RUC neighbourhood-watch patrol from the Clogher station in Co. Tyrone.

Sarah lived on a farm off the beaten track. These officers kept an eye on her.

She had no electricity or piped water.

She's got mischief in her eyes; everyone is smiling, but her glint and demeanour suggest she knows something we and they don't, as if to say: 'What's all the fuss about?'

Sarah has since died.

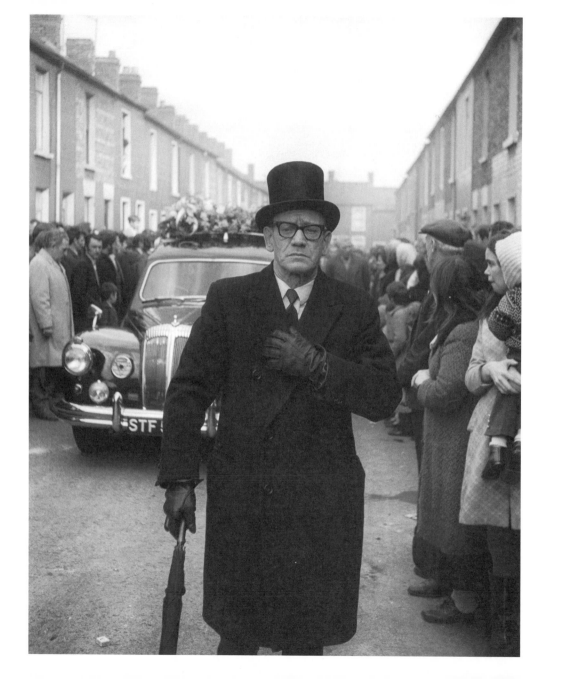

An Undertaking

When my face was in need of a skite of water,
my Fermanagh granny used to say:
'If you died with a face like that,
no-one would wash it!'
… just before visiting
the writhing corners of my mouth
with her spit-rich scented tissue.

Yet, there's you,
a tail-coated tightrope walker of sorts,
with a face to end all wars
for a day, at least.
You negotiate your umpteenth
high-wire traipse
between Belfast-bricked beholders,
über-mourners, gorged on grief,
your umbrella poised like a staff,
to stave off
attempted resurrections or interventions,
divine or otherwise.

Your jacked-up valance brow,
furrowed at high-noon,
hung like drawn-back drapes,
vainly shadowing over-exposed eyes,
eyes, now occupied
by what the dead left behind,
as you hand over
the good from afar,
and the far from good,
to the jaundice-faced pallbearers;
eyes that have seen too
many widows born.

A weather-beaten mascot
for a transient flock,
gloves donned & with top hat,
but still, no circus,
despite all that.
You chaperon along
the hand-wringing cortege

on a schlepped
last death-waltz
forevermore.
A sorrowful shuffle –
any erstwhile sign-of-life
ceremoniously annulled.

Not an undertaking taken lightly.
Not a day for an:
'It'll do rightly.'
A lifetime of fine-tuning,
adjusting,
a touch of the elbow here,
a supportive arm,
angled and craned, there,
like an inclined boom
to a still, beating chest;
precisely the right degree of respect
for the fallen.
And in return?
A decorated title reserved just for you
for that's what the weary do:
A rueful ringmaster
announcing the final act,
sweeper-upper of smithereens,

death-march man
for all but one season,
a preened grief-keeper,
undertaker.

As you lead your captive,
Lurgan spade-faced audience
down Doubting Thomas street,
proctors and probers,
meddlers from the Ministry of Grief
take aim with magnifying glasses,
spirit-levels and clip-boards ready,
parsing up your jib and brogues,
bedevilling and defiling
your every move,
hunting hopelessly for
that white-coat effect,
while the hard men from
The Board of Widow-making
hide out in the open.

Either way, you'll have
the measure of them all
one day.
No more the clown receiving

a dressing-down
for over-doing it.
It will matter not for whom
your grim features
are displayed or whence they came,
whether learned,
heart-felt or other,
adorned where the
vermillion border
tapers into the creases of your
pruned, pursed lips,
the *cul de sac*
for the culled.

Behind the Lens
and
Between the Lines

An Undertaking

This piece was written to the photograph.

Daniel Rooney's funeral, 27 September 1972, Belfast, Northern Ireland. The year of my birth. Daniel was a Catholic civilian, aged nineteen. He was shot by undercover soldiers at St James's Crescent, close to his home in Rodney Parade.

Understandably, some people baulk or laugh with incredulity when I tell them that this photograph used to hang above the fireplace in our living-room. It's something you couldn't but notice, even when you weren't looking directly at it. It was just always there – lurking in the shadows. Then, one day, I took it out, placed it on a stand, stared at it, and started writing. It was one of the few occasions where I wrote the majority of a piece in one sitting. I had a feeling that it was almost writing itself, for my fingers tapped words guided by a dark, weary presence.

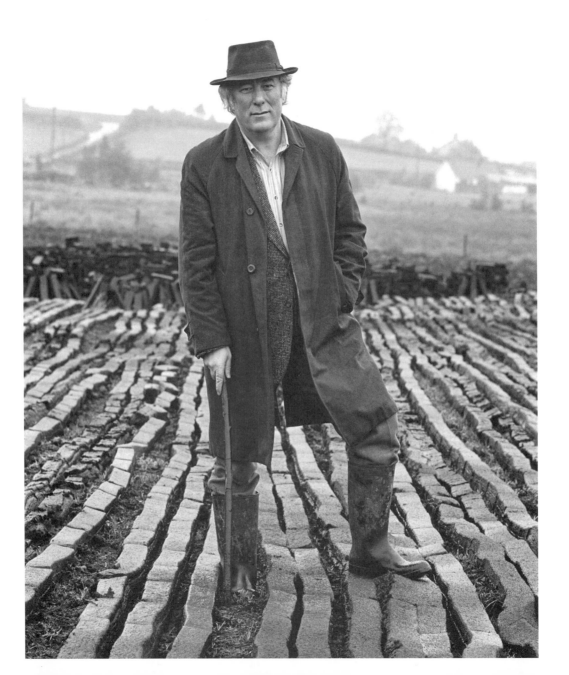

Mongrel Tongue (Between You, Be It!)

You stand before us, a genial Colossus,
above the causes your eyes say you never left.
But as we well know, you don't *get* to leave
a place like this; not *really*.
Nor does it ever leave you, not in peace, at least.
You've been away, but have a look that says
you might have just met yourself, coming back.

Like Hiawatha and Dekanawida,
promoting their 'great law of peace',
you, a servant to the great idea,
followed your own primal laws back to Bellaghy
and beyond, in an effort to unite Planter and Gael
with words, forerunners to the real thing,
the fruit of your labours.

You stand, no mere sapling, in your father's coat and cap,
bridging the gap between Homer, Kavanagh, Yeats and
tomorrow.
In your own dominion, faithful to what witness brings
from darkness, a transient no lands' man,

very much at home for someone whose solemn calling
resulted in physical flight from the land.

Standing steadfast, dug-in, reminiscent of your lupin,
standing for something, for someone,
my *fathographer* for one.
He, the framer of captured light, drawing you out
of the day and into his camera, entreating *you*,
a framer of futures, to rise to *his* occasion.
This homestead pioneer, facing my father with
equanimity, human tripod, legs and golden bough,
mirroring and imploring *him* to rise to yours
and mark *this* moment.

I'm sure you're wondering, what the forecast is doing
a day like that, as you gaze out at high-noon and into the
conjuror's camera. I'd say, plying *his* craft
he preoccupied himself, and the space between you
with readings of light. It may well have rained before
seven, but for you, there would be no let up.
Why *wouldn't* you break for the border?

For a bit of peace, but *in* peace, would it ever leave you?
You mightn't have bothered leaving in the first place,
for you are as close to the poorly province as you've ever
been.
Your one true north, a constant companion, a sheep dog,
shadows your every move as you tend to your flock,
from a remove.

Even with the break in the clouds, the cows
in the fields have no corners left to run to or lie in.
In this dead air-scape, something fierce ails Ulster,
some culture or other – its scab – picked at one too many
times.
To truly see Ulster's wretched rupture, you would take
physical leave of absence, or as some would have it:
Heaney missing in in*action.*

This burden of perpetual inspection, makes yours
a hyper presence, clasping futures and pasts together,
narrowing gulfs that keep us apart and wary.

Blindsided on all flanks, every breath tested
for traces of toxic tongue, assigners of sides and flags
bark orders, and snap at your ankles from the sidelines:
Heaney on trial.

Whatever the weather, this much is certain:
Incertus has left us, for good.

Back in at the foot of your Helicon there at Slieve Gallion,
I like to imagine this as the spot where the daughters of
memory, first revealed themselves, baring nothing but
bones to a voyage.

Your pact would see both vessel and mind divided in
three, between ancient Derry farmlands, the Garden of
Ireland, and Sandymount Strand, with smatterings of
stopgaps and halfway houses along the way. Your split
existence, continually rising to all shades of persuasion
and occasion, as you envelope a hurt with words, as you
might an undead parent, in a dream, one last time.

At the moment of capture, your father's vessel
– no longer straining between the planes
of the god-fearing and the god-less –
has been absent for two years, your mother's, four.
In your present, *then*, dressed in your father's hat and
coat, is perhaps the closest my old man would come
to photographing father and son for that moment,
fleetingly reunited.

Might you have returned to seek council with his ghost,
a summoning from the *undiscovered country*
as you hide out in plain sight?
Drawing him near, keenly gazing inward,
while keeping an eye out, for what *we* can't see – yet.
Sizing up shapes of things, with endings only you have
been partly privy to – which one *we* get could hinge on
how attentively we listen – *if* we listen – as you imagine
us into being more.

Foreteller of tales, wind in your sails, *divil be the tail*,
hurling hope and harbinger skyward
from *in medias res* into conceivable futures in verse,
loaded with code, Ulster possessed, speaking in tongues:
Planter patois, Imperial Lyric and native Gaelic,
all tongues you beseech and graft to cohere, as one.

Ulster's troubles however, would not be worded or
spirited away by nib or nuance. Imagined futures and
reconciliation would need to be envisaged, by rival
tribes for us to begin to dream *that* dream. We're too
close to it, but you, out on the edge of things, up on the
rafters of your mind, tuned into our quandary, a conduit,
nudging us nearer a hard-cold fix in the mirror, hoping
that we might just catch a glimpse or find something of
ourselves in the *other*, in a hidden yet familiar Ulster.

Today, your carriage is planted like a Chieftain's.
You cover forsaken terrain, from the confines of a febrile
and fertile *other* ground betwixt-between tribes who
give you equal welcome, speaking *for* no one and *to*
everyone – if they'd only listen.

Back before us here, you stand sentinel
at the un-wellspring, guarding buried secrets,
pursuing mangroves down to their unnatural end,
hoping to cut clean to the quick of a shared predicament,
writing wrongs.

Sneer, jeer, snipe and jibe – some of the worst
things the Irish do well. Yet, devoted you remain
to the heady playground, dipping in and out of storms,
words soaked to their skin, waiting their turn,
vowels jostling, buoyant still, in treacherous waters.
Your quest will exact its own toll –
they'll round on you yet, left, right and dissenter.

Your path would not be beat through bogland –
this land was not for your hands to harrow.
Part province, part region, where one dearn't put a foot
wrong or heard to be singing the wrong song,
or the right one.

What *won't* you now face on your onward quest,
with *phantom limb,* ancestral link in your right hand,
anchoring you in Toner's bog, guiding you on?
The same limb will haunt and hinder, and harness too,
the necessaries to see a saga through.

On up ahead, fellow-voyagers will one day be done
mincing words, compromised by time.
They'll have to say *something,* whatever they do,
and some, with fortune, in the absence of *animus.*

The stoic Finns hold that *Silence is golden*
– *hiljaisuus on kultaa,* their hour held, not for fear of
reprisal, or survival, but from a natural state of being,
a measured economy of contribution.
But on the other outskirts of Europe,
in our jutting out-post, *houlin' yer whisht,* might just be
the difference between living and dying, or worse.
It's where silences mean something, spaces dug into
sentences, pauses, the unsaid, tongues like kites,
flapping in the wind, enforced vows of silence,
uncertain speakers muzzled at an intersection,
chewing on loaded words like cud, forever splintering
our wooden tongues.
What fails you, ails you.

Levellers will level and Thomas will doubt, no doubt.
Let them.
Like Dedalus on a skeleton, you will constantly
careen between the chute of two poles,
up on the outermost boundary of your wonder place
else, suspended between flight and fight, kneading
words like bows and braids, like dough on a floury page,
reasoned and rhymed into previously only dreamt-of
co-existences, commingling. For we were more alike
than we'd like to let on, but for you, there seemed to be
only ever one way out, *via* your crocheted words,
into and through other.

Many will hear and heed your new song and
no work of yours will ever send men out to die,
and that *something,* is already *everything.*
Instead, you will us to be the Sunday-best versions of
ourselves. A linguistic mixed-marriage, runts of the
litter, reared as your own, your wording the gold in the
glue, the bright sun on our mongrel tongue.

Sankofa bird-like, you're reaching back and pointing
forward. Joyce's necessary nod has given you plenty to
ponder, with vows renewed, your receiving station is
now lit up like a runway.

Having foregone the apple of grievance,
a new tongue, must become a land all of its own,
a ground for framing futures.
Rambunctious Ulster, cheek and jowl,
between you, be it!

And now, some thirty years after you stood
in that bog, the vessel for your heart and soul
has since betrayed you, yet you stand as tall today
as you ever did.

You took us way out beyond the edges of ourselves,
to the great divide where the tongues collide,
where the good in oneself, can be seen in any other,
in those hidden places and faces of Ulster,
a starting place, a home-place else.

Behind the Lens
and
Between the Lines

Mongrel Tongue (Between You, Be It!)

This piece was written to the photo.

This is a 1986 photograph of the poet Seamus Heaney in Bellaghy, Co. Derry, wearing his father's hat and coat, and holding his father's stick.

I approached this piece as though I were talking to Heaney at the moment of capture, and with the power of hindsight and a life lived from then to now, I glance at his journey to the point of capture, lingering somewhat to converse with him in his present – what he has achieved and what he will need for the final stretch of his odyssey, by describing the shape his life will take, post-photograph, and into his and our futures.

Compelled to revisit this photograph time and time again, this one would not be written in one sitting – an order, too tall, given the subject matter.

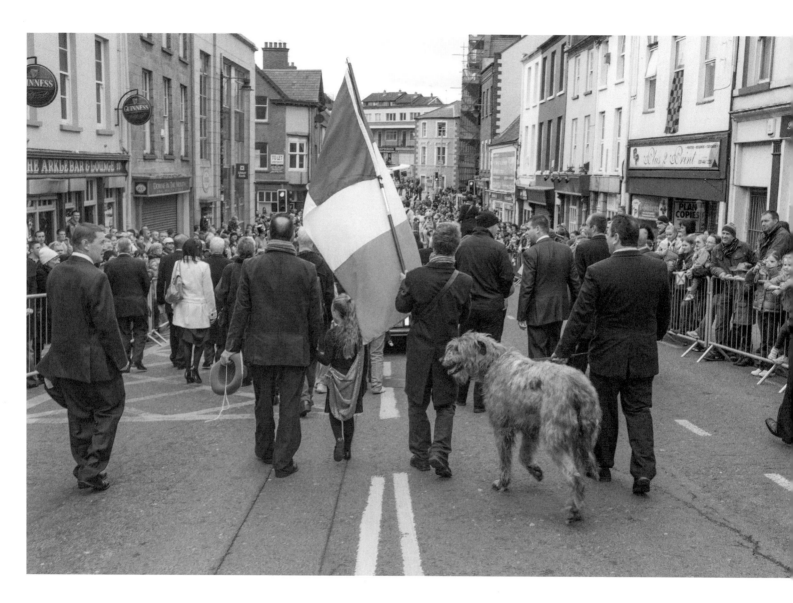

The Most Trying of Colours (The Trickler)

… all real unity commences
In consciousness of differences …
–'New Year Letter' by W.H. Auden (1941)

I used to sit beside a guy in maths class
who was obsessed with the Republic's flag,
or as he would have it, the Trickler –
a flag that could do tricks.

No joke – he could spend the whole class
with his magic markers colouring in
the green and diluting the orange,
and since maths wasn't exactly my thing,
I watched him, out of the fascination
it would bring, and bewilderment.

He'd go to great lengths with his ruler
to frame the panels' boundaries,
taking great care so that the colours
wouldn't over-lap or run,

as that would send him into an awful flap,
where pages would get ripped out,
scrunched up and chucked
in the general direction of the bin.
Those boundaries were there for a reason!
And so, he was back to scratch.

I mind loving the chemical stench
the shiny glittery-gold pen released
when let flow, bleeding and sniffing
into the four corners of its panel.
When he ran out of gold, yellow would do.
The icing on the cake came in the form
of his team's name – Celtic F.C. –
oozed with a baker's precision
as if from a piping-bag.

Once finished, he'd admire his handiwork
before doing a curt drum roll
on his jotter-skinned snare drum

65

and a lap of honour
around his very own Park Head.

Then he'd start all over again.

It's St. Patrick's Day on Irish Street,
the same street that housed my first nine years,
in a town that lays claim
to the Patron Saint's resting-place,
whose grave sits right next to the old gaol there,
in which they hanged
the man from God knows where.
Claimed by both sides, *and* Armagh,
the saint is back by popular demand.

With the colour-guard before us,
the central figure of the Ulster Cycle,
Cú Chulainn,
seems to be giving Culann his due –
a hound in lieu of the one he'd killed
with *sliotar* and stick as a child.
He's seen, not toeing, but walking a line,

flanked left and right by comrades
in a controversial procession.

And sure enough, there it is,
the tricky Trickler, causing tongues
to flap three sheets to the wind,
at it again.

They could be going into battle
for the soul of Patrick, to claim him
outright while they're at it;
it's about time we all knew
what shoe our patron saint kicked with!

What do *you* see when you look at the Trickler?
The past drawing near and gawking back at you?

This most trying of flags is a tricky one:
Perhaps it's weathered one storm too many,
been left out in the rain too long.
Since its inception, it has provoked ire,
finding it tricky to trudge the mire.

It was only ever able
to rally Nationalists around it
and unite Loyalists against it,
symbolising division at best.
'Aye, *themins* disowning it,
if ever theirs to begin with!'
Claimed, unclaimed,
revered, spurned,
hoisted and burned,
we bicker and gurn the days and nights through
despite the high hopes the French had for us,
envisaging a promotion,
not a subversion of social cohesion.

Partly or universally rejected
by colliding tribes,
the Trickler feels like a flag in flux,
is every bit down on its luck,
and the Irish just make it stick,
no matter what.

Green white and *orange*?
Three's clearly a crowd.
Others know when they're not wanted

and if Billy doesn't want it, well, so be it!
We'll change it!
Green, white and *gold* – the remould!
Not sold on gold?
Aye, the Trickler's an oul' stickler
for the shades.
You'd think the flag, like any fabric,
would have come with clear instructions:
'Do not hot-wash as there might be ructions!
Colours may run or fade in time.'
Clearly, the instructions were lost in translation.

If they thought they could get away with it,
some dissenters *and* rebels would
take the scissors to the orange bit.
I believe this one's up to the people.
Perhaps we need to meet our troubles
half-way in, betwixt-between
our orange and green?

How would the white cope
with the limelight?
If white reflects the light,
then fear, another ancient enemy,

mushrooms in the dark.
We could see that central panel
as a liminal, made-safe, breathing space,
a listening-pool for the curious.
The opposite of pitch-black,
it can never be pitch-perfect.
But it is hope's waiting-room,
with an endless Lahaina Noon
where shadows disappear.
We may see our reconfigured selves
looking back in wonder,
something new, yet familiar
in the forbidden faces of Ulster.

This dwelling-space is a lighthouse if let,
a halfway-house on the way home.
It has no corners to fight.
Those bold enough to venture into it
will secure their own rewards;
The centre *can* hold.

Of course, it's nothing new:
it's just frequently over-looked,

forest-for-the-trees stuff.
It's always been there,
and we know where we've been,
where we are, but have no idea
of where we're going.
Backwards is not an option,
and going it alone didn't work last time.
By standing at the threshold,
and not the precipice,
we just might make it over the line.

That said, it can be a disorienting place:
Guards need to drop, baggage off-loaded
on the way in – an honouring of intent.
There'll be no safety-net,
but there is safety in numbers.
The history-hoarders should quit
keeping score, for numbers
are dead weights and drag a body down.
No more breeze-blocks for feet,
and shoulders fit to collapse.
Let's lighten the load for the road ahead,
for it's likely to be a long one.

Behind the Lens
and
Between the Lines

The Most Trying of Flags (The Trickler)

This poem had been started in its own right, but the photograph helped give it legs and focus.

(Then) Sinn Féin Councillor, Eamon Mac Con Midhe with his Irish wolfhound, leading a procession on St Patrick's Day, on Irish Street, Downpatrick, Co. Down, Northern Ireland.

It was taken outside the house and shop where I spent the first half of my childhood, before moving to Church Street.

The procession had caused some consternation over the flying of the Irish flag. It's been claimed that a committee had previously agreed on another, more inclusive flag but that Sinn Féin had, at the last minute, decided that it was the Irish flag that would fly.

71

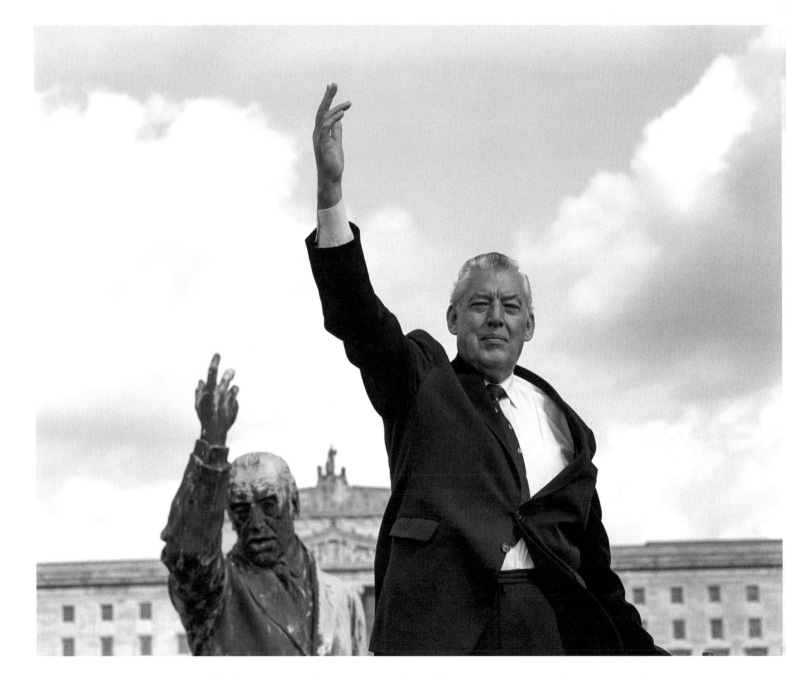

Carson-Parson

Sir Edward Carson had a cat,
It sat upon the fender,
And every time it caught a rat,
It shouted 'No Surrender'.
–Nursery Rhyme

Some ask if there's any rumour in the truth
that Carson's statue is deliberately positioned
with his arm stretched out before him
in the direction of his native Dublin,
and by extension, the Irish Republic.
While it's something we can grab on to
as an angle, it's too obvious, too believable.
Since Carson saw partition as a betrayal,
he could be directing his displeasure at the border.

A man can be a lot of things in a lifetime –
he can show his many sides if he lives long enough.
As the son of a Catholic forester,
it was no surprise that my father,

once upon a Civil Rights Movement,
found himself at loggerheads with certain folk.
Many's the placard he held high, but today,
You, The Revd. Dr. Ian Paisley, MP for North Antrim,
are the subject of his elevation.
Never one to miss an opportunity,
you are, quite literally, rising to the occasion
on a whim and a prayer.
And there's my da, the master image-builder,
about to capture and hold you captive,
and not just for the day that's in it.

His positioning of you – a man not known for a love
of graven images – next to your mirror-image,
demonstrated a canny understanding
and recognition of the grander scheme of things:
Placing you on an equal-footing,
on the same pedestal,
was as close to an official affirmation
as you were ever likely to get.

With eyes fixed on history, cock-sure,
you're not only looking into my father's catcher –
you're looking at all tribes alive and yet to be born.
Your face an open-book, it reads:
'Not on my watch!'

Coming out from under Craig and Carson's
shadows, this photo acknowledged that you,
the son of a pastor who had served
in Carson's Ulster Volunteers,
had inherited a mantle and that Ulster's manful loyalist
leadership would remain true to tradition.
You were making it so.

Standing there, you are the cat that knows where the
cream is kept on Ulster Day and on every other.
You know something we don't,
part-bravado, part-gloat,
but pride comes before a fall
and it's a long way down …
but that's another song.

This is 1985 and you're as upstanding
as a god-fearing man on a Sunday could be.

Are you toasting Sir James Craig,
who stands, less elevated,
in the cool entrance-hall
of the constantly-capsizing ship
to your backs?

The Ultonian character traits
– temperance and virtue –
would certainly ensure that a tumbler
of the devil's buttermilk would never be held
in those hands or pass those lips.

Might your upward arm-sweep
be that of a long-jumper, or a gymnast
signalling intent, one step a year,
sometimes backwards,
for the next twenty or so?

On a different day, perhaps a javelin
is being aimed at all embodiments
of Popery or treachery,
your deportment in accord
with a familiar code,
a peremptory-call to all of Ulster's unionists?

Kings at Arms?
A relay race to the bottom
or to the Promised Land?

Like Zionists, old Ulster low-land Scot stock
were forged from fire and brimstone,
and cut from the same cloth.
Even if that hand in the air to your right
was one of the first to wrap itself around a hurl when
Gaelic games first entered Trinity College,
it's best remembered for gripping
the public's imagination for decades
and now, captured in a photo-finish,
it hands the baton on, message scrolled inside.

Mirroring Carson, channelling Chamberlain,
you *hold in your hand*
the remnants of a Covenant.
It's your turn now, come what may.
The Uncrowned King of Ulster,
perfectly taken off in this moment in life,
the very incarnation of unionist integrity
and dissent.

Your bluster was always a function of
your imposing figure.
A bellicose blunder-bussing scattergun of a man,
you seemed to claim that the word *defiance*
was of your own minting.
I wrack my brain trying to think
of a word for *defeated*, yet *defiant*,
and 'Ulster', was all I could muster.

Here, caught in an uncharacteristic act of silence,
yours is the comportment of an inheritor.
Resolute, a watchman of flock and legacy,
seen here the same year of that footnote,
The Anglo-Irish Agreement,
for a brief moment, you united all shades
of green and orange by calling Thatcher 'a Jezebel'.

Hurley-sticks and stones may well break bones,
but titles you too had plenty:
Doctor, Reverend, Honourable Member,
Lord and Baron.
You've been called worse –
The Provos' best recruiting sergeant, for one.

Carson's bar set high,
was he really fit to outwit Wilde?
This is no day for whimsy, this day is about Paisley,
they can say what they like about you,
but you knew the importance of being earnest;
and boy, were you frank, were you what?

Whatever the theme of the sermon,
you'd been gifted with pipes to *learn* them
and boy did you know how to use them!
The same pipes belted their way
through the Troubles.

Your messianic, firebrand oratory style
came from the American Bible-Belt,
but here, suddenly silenced by shutter-click,
no sound-bites are required but it is still
a rallying-cry for all that.
To think you were partly the reason
we have an actor in Liam Neeson –
funny old world for the living.

If my da had read your tea-leaves that morning
and told you one day
you '*would do what must be done*'

and kneel and pray with an arch-enemy from Derry,
you might just have keeled over.

Kneeling, praying and kissing the hand
of old enemies may have been necessary,
but for your erstwhile brethren,
it was a breach too far.

If delivering peace was your *coup de grace*,
your last years were to prove your undoing.
Abandoned, your flock astray,
the wolves smelled blood
and shed their wool in your final hour.
The good shepherd, now a lost sheep,
betrayed by the fairest of weathered friends
– new enemies, and with talk of Lundy –
it became impossible to tell left, right,
and Dissenter from the other.

Despite the fair-weather friends,
what history knows is that you and McGuinness
were the only ones who could do
what needed to be done.
You both brought your respective flocks
into a pen of your own making.

If people were honest with themselves,
they might just admit to missing
the pair of you there, for work got done
when you ruled the roost,
despite or because of the tee-heeing
about Chuckle Brothers.
Behemoths, in your absence,
a vacuum has left us all wondering,
Was it all just a dream?

Looking at this photograph in recent years,
I wonder how Lord Carson would
have taken your overtures.
Might you have ever felt the need to offer
an explanation to him as to why
you did the deal, inviting the Croppies
into the citadel and bedrock of Ulster Unionism
at Stormont?

I imagine you telling him:
'Well, I did what I had to do to keep the Union safe…
and safe it is. Needs must my friend!'

Behind the Lens
and
Between the Lines

Carson-Parson

The piece was written to the photograph.

This photograph was taken in 1985 at Lord Edward Carson's Statue, Stormont, Northern Ireland.

The man operating Paisley's lift was on *terra firma* and when it suddenly shuddered, Paisley looked down and said: 'I wonder who's stamping that man's card!'

Then the wind got into Paisley's eye and he said to my da: 'Hold on, my friend, till I get this water out of my eye.' So, out came the hanky and all was good, and my father shouted over: 'Dr Paisley, I hope it's not holy water!' and, without missing a beat, Paisley retorted: 'Yes, it is!' before spelling out: 'W-H-O-L-L-Y.'

It's easy in hindsight to recognise this as being the golden age of Unionism and that Paisley needed an iconic photograph going forward and that my da handed it to him on a platter.

Ian Paisley Jr told my da that it was his father's favourite photograph of himself, which, as flattering as that must be, it's not surprising, given that it tapped into the moment in the way that it had.

Lord Carson played hurling at TCD; he regarded partition as a betrayal as he wanted the whole of the island to remain in the Union. Anomalies: this is the man Paisley modelled himself on -- the stuff we didn't know, or we didn't want to admit to knowing. It's all about having a peek: who's he emulating? Who is *his* graven image? Where did he come from? Why is he mirroring Carson? There are layers upon layers and many more shades of grey. Look into it, look at it. Get into it, get in at it, because the answers are all there.

By the time the 'Chuckle Brothers' were a thing, it appears as though it was high time to live by Carson's words in addition to his actions, gestures or other, for after partition came into being, Carson said:

> From the very outset, let us see that the Catholic minority has nothing to fear from the Protestant majority. Let us take care to win all that is best among those who have been opposed to us in the past. While maintaining intact our own religion, let us give the same rights to the religion of our neighbours.

My paternal grandfather, Johnny Hanvey, died on the morning Stormont fell in 1972, the year of my birth.

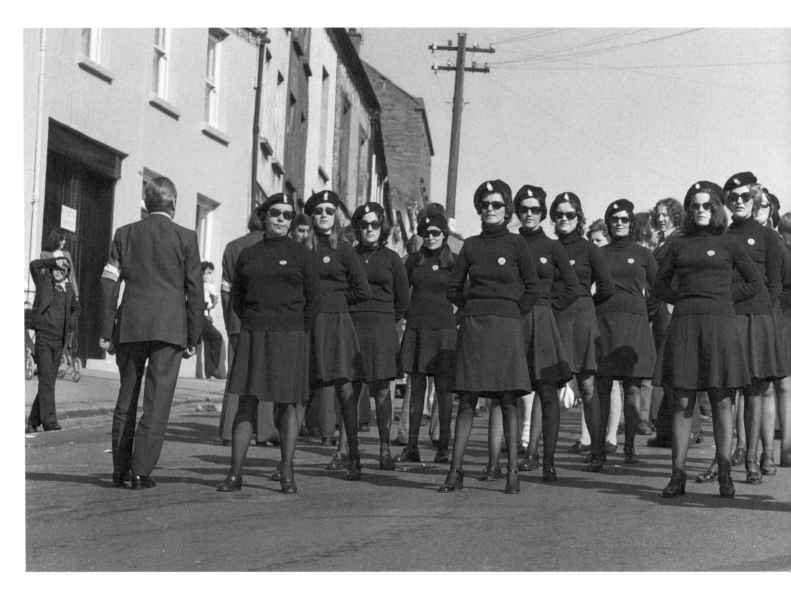

Easter 1974

Most offer:
'What a powerful shot!'
… without saying why.
There's no denying its visceral,
punch-packed potency,
but as hard as I try to hook a why,
I too, come up short … at first.

An uneasy photograph to over-think,
I feel it more than most,
though the gulf between my head
and gut widens the more I give
these feelings a hearing,
making me all the more vigilant for it,
as I hunt down the imagery within.
Like the picture itself, words are loaded,
primed like booby-traps on a bridge,
awaiting the heavy train of thought.

… Proceeding with caution,
I note it's Easter, 1974.
Location? My hometown of Downpatrick.
But there's an unnatural order of things:
not everyone's playing 'Hide the Egg.'
Here on in, I realise, I'm on my own.
Cut loose, adrift in the familiar,
I find myself on streets where signs
have been replaced with symbols.

Some 200 metres away,
I know there's a rage of police constables
beside themselves, choking on barrack-tea
as reports come in that traffic is at a standstill.
The local *Cumann na mBan*
– paramilitaries who daren't assemble –
have just appeared,
apparition-like and eerily at ease,
freely associating in plain sight.

In that instant,
I'm sucked into their only
visible weapon – their *über* presence:
Defiant to a fault, one thing is certain:
they don't defy description – *they demand it,*
barking orders through sealed lips and time
as they lay claim to space itself.
Ours is attention not requested,
but sequestered – a declaration
writ large in black & white … and grey.

On this Paschal Sunday, all shades of green
are commemorating one shade of blood
shed for Mother Ireland; but this faction
now takes aim at former comrades
who were then seven worlds away
from silencing their own guns.
For the gathering before us here,
poor old Ireland
was bleeding out of view.

Toe-to-head in pitch-black,
to some, they are a murder of crows –
chicks of The Morrigan who are cuckoo;
To others, they are the daughters

of Gaelic warrior queens – Nessa, Maeve, and Alva –
pain-incarnate, grieving for losses
and bridling over opportunities missed
through no fault of their own;
For others still, of a more classical-bent,
they're Amazonian warriors,
a subversive *Phallika*, perhaps,
cocksure, like Gaddafi's 'Revolutionary Nuns'.

Did these weaponised women
arrive here of their own device,
or under duress, following orders?
Is their display the envy of their peers?
Made safe by ceasefire and splinter,
the potential threat is cosmetic,
their post-split remit being defence
and retaliation.
For the powers-that-be,
these foot soldiers have been
stood down.

But still, they're here:
Patch commandeered,
photographic space is all but shanghaied,
save for the outer edges,

where some match-stick-men
faux-marshal the ruly crowd,
while others flounder for purpose,
all the time conscious
that they are being watched
by those outside the frame.

The potential for spectacle is
not lost on our troupe:
Erect, like sundials gathering darkness,
they are clocked at ten.
Some feign a smile, revealing
bemusement, a lightness even.

Still, they won't be hemmed-in,
there's no going back to *that* –
these women will not be told
or held captive by old Ireland:
For sure, they'd all fail
Sister Philomena's kneeling-test,
and in more ways than one.
Back then, to pass muster, those skirts
would have had to have been
a shade more southern,
and those heels kissing

to ensure a ladylike demeanour was kept
on that, and every other day, Amen.

But Sister Philomena's a shadow now,
if she ever existed at all,
and her girls are now women
who've grown into a very different assembly.
Today, they're channelling all that talk
of demeanour to a different end:
feet at shoulder-width,
right hand in palm of left,
making invisible Vs behind backs,
they are prize-fighters dropping
their guard, feinting, goading their opponent
into an assault of the senses.

They dare all who see them
to doubt the pride with which they wear
that badge on breast and beret,
and challenge those who think
that common passions
reside behind their stony-faces.

They are, however, scrutable to the last,
for their dark glasses

– intended to anonymise –
betray them,
serving only to remind
watcher and witness alike
that a mother's eyes,
or the gaze of a lover,
wife or daughter
can fix them in a heartbeat …

My cover blown, I beat a hasty retreat
towards my comfort-zone.
My last view is of the background
where a telegraph pole stands
by chance in cruciform –
it's Easter, after all.

Behind the Lens
and
Between the Lines

Easter 1974

This piece was written to the photograph.

I was two years old when this was taken.

Official IRA women – members of Cumann na mBan – on Easter Sunday, in Scotch Street, Downpatrick, 1974. 'Cumann na mBan' literally translates from the Irish language as 'council of women', but the organisation itself habitually refers to itself in English as the 'Irishwomen's Council'. Most outsiders would simply recognise it for what it is – at least in its incarnation in Northern Ireland, though maybe not in the Republic of Ireland – as a paramilitary Women's Brigade.

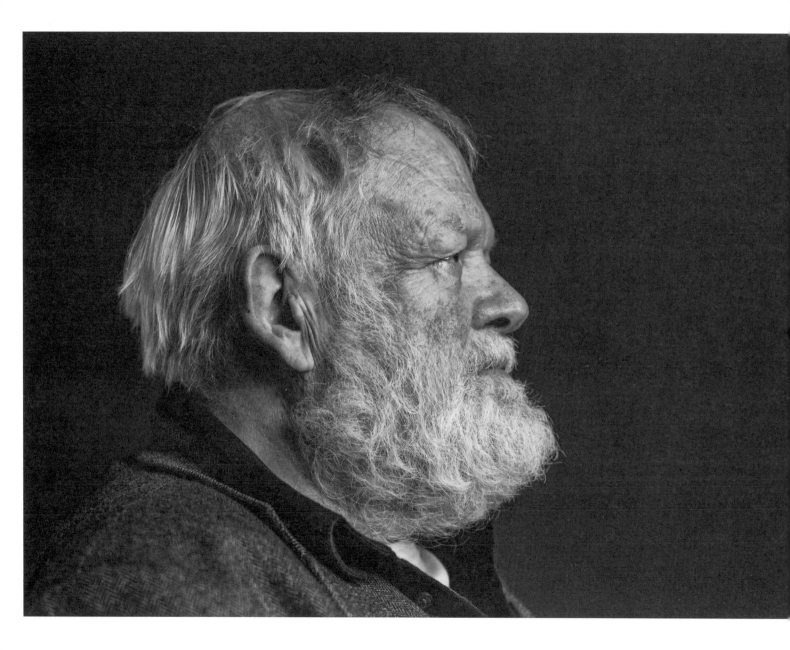

Longley's Lists

Longley's lists,
as long as your arm,
systematically ordering
chaos to a stand-still,
one item, one line
at a time,
taking one's mind off
where to be.

And with peace
all the rage,
you'd wonder what
he's writing about now.
Of course, the answer is:
the same things
he's always written about:
the stuff of life –
death, rebirth, and this
unnatural world of ours.

If you were to figure
Longley's lists as a line,
it would reach down to
Thallabawn, at the
rock of the wall fern,
his soul-scape
of Carrigskeewaun,
and up on over into
the western Highlands there,
intertwining at Lochalsh,
and back down in, and
across to his beloved Belfast,
a stop-over,
to be on the safe side,
so as not to forget
where it all started …
before going about
yet another lap,
still wanting, still wondering.

All resting-places
for the restless,
a *quare* route
for the rootless.

The lists and lines find
homes in all of us,
bedding down, done roaming,
even if their servant,
whose home is in the poem,
is a No Land's Man.

Behind the Lens
and
Between the Lines

Longley's Lists

A side-profile of Michael Longley, CBE, and Ireland Professor of Poetry (2007–10).

This is one of my favourite photographs of one of my favourite poets. It would put you in mind of a side-profile mugshot or police line-up. Michael, lifted for crimes against the 'Lists Act!' He *is* a visionary, seeing, eyes fixed on futures.

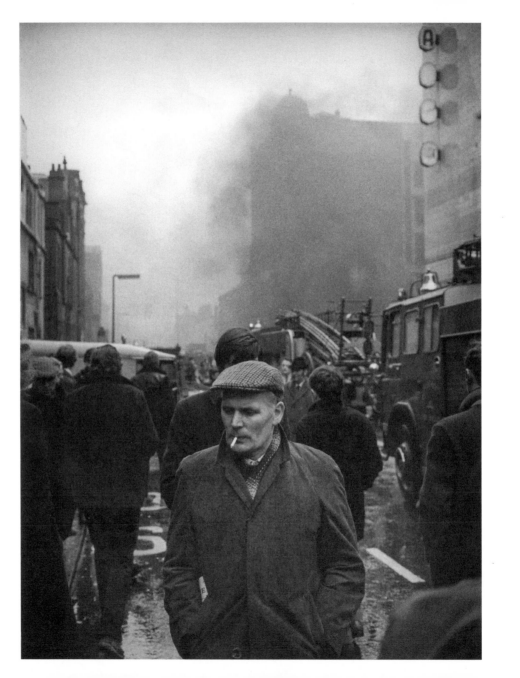

Perspective (Another Day in Paradise)

Outamaway, there's nothing to see here,
business as usual.
This is Belfast, hadn't you heard?
The natural disorder *a-hings*,
keep calm and to hell with the lot of them!
Carry on and carry on.

What's all the commotion?
Been there, undone that.
I'd be late for work
if I'd a job to go to!

What's your longing?
Meteorite, meteor wrong?
Brilliant, the rain, that's all I needed!
On *topa* all this!
And me only after binnin' *me* brolly!
Nar, I'll get soaked to the skin!

This place would do your head in, so it would.
Don't be looking at me, I'd nahin' to do we-it,

I've no dog in the race, sunshine.
Who was it this time?
A dunno which is worse,
that ruckus behind me
or your clicks and whirrs!

Don't go writing me into this,
making it about me,
fer it's like something you'd do.
This place isn't the only
monkey on my back!
You should be asking:
'Who's *yer* faceless shadow of a man,
up my backside!' Aye, him!
There's two of us walking away.

I've seen it all, what of it?
What about them space cadets
behind me running in to it,
they're not half-wise.

What are they hoping to find?
Hopefully not a loved one.
Alright, it's just, this place hardens you sometimes,
and it's only getting started.

Now *this!* I'm now captured
and forever associated with what ails us,
thanks to you!
Browned off? Wouldn't you be?
And they're supposed to be doing this
in my name?

First themins, now you!?
Is there nowhere a man can get his head
showered around here?
Do I look like I'm in the mood for puns?
No photies, alright!?

Does it matter, says you?
To tell you the truth,
I just came out fer the *Tele* and *Woodbines*
and to go for a wee dander.

Now I've dust in my eyes
and there's a fierce ringing in my good ear
and no *Tele*!
Aye, but so what?
Just another day in paradise.

Like the police, cameramen –
never around when you need them!
You should have been here
when they were planting it.
Some good you'll do.
Day in, day out.
Different day.

Tell me, what's acceptable
about this level of violence?
What have we become?
Just dark days in the rearview.

Behind the Lens
and
Between the Lines

Perspective (Another Day in Paradise)

This piece was written to the photograph.

An IRA bomb in Belfast city centre, *c.*1973. The photograph shows a man walking away from a bomb-blast, while those around him are seen walking towards it. One can only imagine what's going through his head. His demeanour encapsulates a weariness … and to think that the most recent chapter of The Troubles was in its infancy when this was taken and that conflict would rage on for another twenty-five years.

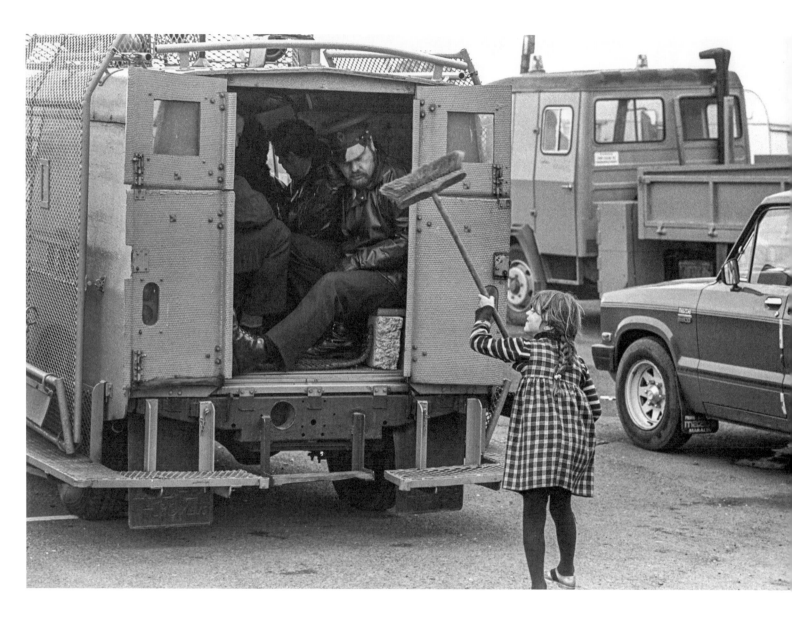

Trigger Treat

This night of particulars
was thick with a mix of coal-turf fug;
even the darkness had a scent of its own,
fuelled by the spume of petrichor.

The footpaths and slated roofs
sheened with the oil of the rankling dank air,
while the fits and starts of attempted rain
delayed my mischief-making no end.
I, for one, armed with nothing more
than a handful of party-poppers,
had been spoiling for a fright,
on this All Hallows Dark Eve Night.

This is how it was:
We had moved from Irish Street
to get away from the bombs and
bomb-scares at the barracks.
We weren't long in, when the
off-duty RUC man knocked our door.
My mother was right if only in hindsight –
there were *indeed* ructions.

But if she was mothering, then I,
for want of a better word, was *childing*.
I paid little heed to her advice, on our first
Hallowed Eve on Church Street.

Granted, I had skirted beyond
the confines of the permitted
boundary-line of Pillar Well Lane,
as ten-year olds are wont to.
Still, it was to be a trespass too far –
with outcomes, the worst of which
would not have made a great birthday-gift
for my old man, who, on this night,
some thirty-odd years earlier,
was himself, and for his sins,
born amongst the witches.

I knew I would pay for my infraction,
my excursion being an incursion
into their fretful adult-world.
But for the life of me,
and the me of life,

103

I'll never understand why,
after rapping a door on Church Street,
I spun around, closed the outer gate,
juked down, execution-style,
and faced the door, with party-popper
primed and aimed in my left hand,
string tightly wound around the
trigger finger of my right,
ready for the fright.

And then? Zip.
My sly-rap went unheeded, causing me
to think that the occupants of the house,
like most of the others on the street,
were simply *letting on* to be out.
They were spoilsports, the lot of them,
conscientiously objecting to a just war
between darkness and light,
with curtains drawn tight,
save for a chink to see out
if needs be.

Slumped down on their sofas,
dinner plates on chest,
and with the big-light off,

they hid from wee skitters like myself.
But the blue-hue from the TV,
gave *their* game away.
Warm breath, twitches, sweat –
all fed the focused moment.
As I crouched, the night enveloped me.

But … *no show.*
I was about to stand-down and venture
forth in search of other divilry
when the target came into view.
He creaked the door ajar,
the crack of blackness
complementing the mute orange tones
of the sodium-lit street.
That's when I should have called it a day.
But for the night that was in it,
and in league with the spirits
of the Celtic festival of the dead,
I pulled the string.

Flash-crack-sulphur
and a giddy squib of confetti.
The door responded with a bang
and a shudder, giving me quite the gunk.

But something was *off*, not quite right,
as I tried to scuttle into the hallowed night.

My feet became breeze blocks,
hampering flight, as in the worst of dreams.
And I rued my make-do costume
– my father's overcoat –
into which you could have put me
four times over, and three times under.
My cloak of invisibility?
So I thought, until eight words delivered
in semi-automatic *staccato*
stopped me dead in my tracks:
'Hold it right there!
Do. Not. Fuck. Ing. Move!'
The owner of the words
had commanded time itself to halt.

A neighbour, passing by with her dog,
stood and stared.
I tried to place her face, but couldn't.

Unlike my mother's warnings,
this much I *did* know: these eight words
unheeded, would *not* go.

Is that gun pointed in my direction
real or imitation, brought out one errand,
for this kind of occasion?
A tad excessive, I thought, given our location-
overkill, even.

All of me, right there, needed to believe
that he was *at it*.
However, this was no trickster upping the ante.
It turned out, I had taken a plastic knife
to a gunfight.

I went from being anchored firmly
in the last paragraph of childhood
to being a spectator, with a birds-eye view,
at which moment, I began holding my breath.
I'd forgotten to buy the eggs.
Nor had I given my mother her change from
the butcher's, or his regards, for that matter.
I hadn't bothered to ask my da for the loan
of his coat, or wish him a happy birthday,
back when he still *did* birthdays.

The sulphur lingered, its film clung
to the walls of my nose

and reeked of matches
on a rain-soaked coat.
I had been granted a last-minute stay.
Trembling uncontrollably,
in his right hand,
his gun remained trained on me,
as his left arm reached out
like a snake charmer's,
and pulled down my gaping hood,
exposing a boy's flattened,
matted hair and face – *my* face.

He'd given up the ghost.
His face now drawn, older in appearance
than our years combined, he let out
something between a gurn and a gulder:
'Oh God! Young Hanvey!
I nearly blew your head off!'

I didn't cry, but I wish I had.
At least this would have been
some reaction.

The father's son part I was no stranger to,
the rest, a ripe collection of words,

a fiction by any standards,
let alone for my ten-year-old brain,
words, that still sit with me,
uneasily, all these years later.

I'd be hard-pushed to say which
of the pair of us was more floored
by the ordeal. I'd say him;
he might say me.
But one thing I do know, is that I wasn't
the only one there out of his depth,
on that Eve of All Hallows.

My youth, as intended,
shielded me to a degree
from the magnitude of the moment.
Though, all these years later,
I still don't fully appreciate
how close I came.

Nor have I learned what, if anything,
to do with those words:
'I nearly blew your head off!'
I guess some words cast
longer shadows than others.

From knock-knock to penny-drop,
there's two words for each minute
of intimacy shared, stretched out
over each decade, till now.

The ferocity that propelled his earlier
command had all but gone.
His pre-teary state allowed me the opportunity
to slip back into my childhood
and reclaim my game.

The third time the pointer of the gun spoke,
he issued his second command:
'Go home now and I'll be over
in a minute to have a chat with
your parents.'

When the off-duty RUC officer
darkened our door
he wasn't only invited into our home,
but also into – and unbeknownst to him –
an elaborate game of *Let's Pretend*,
initiated by my mother, who, unlike me,
would not be afforded the luxury of youth
to shield her from this near-miss.

In fairness, she did let him say his piece
before she went about tearing strips off him.

Not everything was decipherable from
the echoed remove of the bathroom.
Their exchange was muddy,
and at times, circuitous,
almost mimicking the nuances
of a political debate.
Though it impressed upon me
how broken-hearted, and irreparably hurt,
the northern accent sounded.

My mother said:
'It's Halloween, for Christ's sake!
He's only a child out playing trick-or-treat!'
If it was satisfaction the off-duty RUC man
was after, then he *too* had knocked
the wrong door.
My mother went into primal mode
and mounted my defence.

It seemed she refused point-blank
to acknowledge our geography.
But there really was no getting away from it –

107

this was our corner of the woods,
a place where something as innocent
as trick-or-treating appeared to some
like a murder-bid.

The off-duty RUC officer was shown the door;
then it was my turn.
But within moments, my mother's stern voice
cracked, faltered, and then fell silent.

Only now, with one of my own,
can I fully picture the deep well
and gush of emotion that the
competing feeling of anger,
succumbing to its false friend, relief,
may have afforded her.
A short-lived, if welcome release
on that Eve of All Hallows.

We stared at one another
for a moment.
Mother, child,
mere figures in a kitchen,
surrounded by a darkness,
both real and make-believe.
Her hand on my head,
my head against her pounding heart.
I felt that if only I could
make it up to her
somehow,
some way,
someday,
I would,
… maybe.

Behind the Lens
and
Between the Lines

Trigger Treat

Our family had just moved from Irish Street to Church Street when I decided to introduce myself to some neighbours armed with *divilment* and party-poppers. Another of my nine lives was used up on this night and it must have put years on my mother!

There's a lightness about this photograph, just as there was to my step as I went out trick-or-treating on the Eve of All Hallows, back when. The little girl is a member of the Travelling Community, and is waving a brush at an RUC officer who had been on the night-shift and appears to have fallen asleep; he is apparently unaware of the attempted brushing. The police had been called to try and move the Travellers on from the Superite car park in Downpatrick. Somewhat ironically, in this photo, the little girl was mirroring what had been happening to her community by shaking the brush at the seemingly jaded R.U.C. man. This photograph's caption at the time wasn't 'Power-nap', but 'Brush with the Law'.

The Way of Them

For Adrian Rice and Alan Stuart Mearns

The man before us,
doing our looking,
is past currying favour;
he has taken leave of his lodge
for a moment alone.
A follower of the Lambeg,
he is dead-beat after pounding
the roads of Ulster for Queen and country,
and now, hat-on-knee,
we catch him in repose, taking in
all that has taken it out of him
but drives him still.

This Orangeman's demeanour is a wee bit off
as they usually wear order like a badge of honour.
We're used to seeing them in sunlight,
rigged-out, bowler hat to hobnail,
upright and uptight, defiant and proud,
and flanked on both sides by stern brethren.
Still, our man is a picture, composed,

sitting there like Billy-No-Mates,
out of the frame
but about to be pulled into one,
all the same.

Once members of the Civil Rights Movement,
my folks weren't blind
to improvements long overdue.
The way it was, or the way things were,
would only serve to get you so far,
yet tolerance was no stranger
in the house anomaly built;
my parents made choices.
Both were blow-ins, springing from
border-town and townland
but settling in Downpatrick,
and I wasn't let forget it.

As a young cub in Brookeborough, Fermanagh,
a Protestant neighbour,

and not for bad manners,
would put my four-year-old da up on his knee
and run him through chapter and verse
of 'The Sash My Father Wore'.
It wasn't long before George Kirkpatrick
would have him singing it,
like Lord Carson's cat[1]
regaling visitors, and him only four,
the Taig next door,
with inhibitions no more.
Not your average rite-of-passage
for a Northern Catholic, or so we're told;
an experience as fond and profound as it is old.

With our ones, there's a sectarian foot-fetish –
an obsession with having to know
which foot one kicks with.
Once, after a show in Hickory, North Carolina,
the poet, Adrian Rice, approached me and said:
Back in the day, we didn't know what your da was.
To which I replied: *I don't think he knows himself!*

As I re-tread old ground of my own,
dotting the lines through milestones,
I forever arrive at each and every how and why:
Holidaying at Granny Hanvey's,
I was often exposed
to names I'd never heard tell of before,
not because my ears had been intentionally closed,
it was just that names such as Armstrong
sounded very composed,
and from the likes of Cartwright and Atwell,
I recall, right well, a welcoming warmth
from what I could tell.

Robert Atwell lived on Main Street there
and always put me in mind of the orchard-chair
he'd lend us to raid apples across from his house.
He had nothing but the time of day for my bounce
whenever I rapped his *dure*,
and my giddy elation when out he'd repair,
all occasion, laying flat his tool-kit for patch-ups
and whatnots, all to tend to my latest deflation.
Flipping the *Flyer* over onto its head,
eager as hell to get me back racing,

1 'Sir Edward Carson had a cat / It sat upon the fender / And every time it caught a rat / It shouted *No Surrender!* – Nursery Rhyme

out the tablespoons sped,
so as to get in at the culprit.
He'd take me through the paces
– the dousing of the tube in the basin
and the application of the patch –
just to get me out of the thick of it.
Finally, after a quick bout of inflation,
The Flyer was spun back into life
with an *All on the house!*

<center>*****</center>

My mother grew up between Banbridge and Newry
in a townland called Shankill.
Though relations did tend to rankle,
she remembers her Protestant neighbours'
sense of charity, and how a member of the Carswells
taught her how to knit,
while other poor left-handed critters
got hit or worse for their 'affliction'.

She recalls how she and those neighbours
all *rubbed along together quite happily*, tier-less,
until old ways got the better of them,
opening old wounds and causing all things familiar

to fly right out the window as the Orange Hall
across the field belted out its blood 'n' thunder,
preventing sleep, and Ma all bewildered now.
Everything seemed designed for show,
and that way they'd stay
till the end of the summer
when Black Saturday helped it return to normal
and the same neighbours would give you a lift
to Mass, though, by accident of birth,
they went a different way.
All the summer felt like a dream for this was just
the way of them, it seemed.

<center>*****</center>

In the early Eighties we moved from Irish Street
to the mainly Protestant Church Street,
one of whose residents sold us the house
we moved into.
Just like in Brookeborough at Granny Hanvey's,
I was once more exposed to Dandy-esque names like
Briggs and McElherne,
or was it Victor and Biggles?

June was always quite a month in our house,
as Ma and me have birthdays
within two days of the other.
Plus, it housed Father's Day, even if my mother
said it was *his* day, every day.
Whatever pocket-money you got
was put past for presents.

My parents were the kind that if they talked,
you listened. I mind them telling me
as we were nearing one June:
'If some of your neighbours don't greet you
at all, or in the same way, during *the season*,
they don't mean anything by it.
Pass no remarks and just continue to say *hello*
if you meet them on the street, the same way
you would on any other day of the week,
for it's just *the way of them*.'

And that was that.
Admittedly, their earnestness
had a sense of occasion,
and its *facts-of-life* vibe grabbed my attention.
I recall how I tried to make it all swing,

wondering if it really wasn't a personal thing
as the phrase *the way of them* moved
around my head, I couldn't help but wonder
if this is what they were like having won the fight,
what would they be like if they'd lost?
Shouldn't *we* be the ones with Lurgan spades
for faces?
It's been a circle I've given up on trying to square.
Maybe 'That's just *the way of them*'
is just the way it is.

Part-preparation, part-education,
it also highlighted a *difference of occasion*
and *one* from the *other, a given* on offer,
another *just how it was*, a new look at the other.
Nowadays, they'd say:
'*It is what it is, son – but nothing like it was, son*'
before a ruffling of hair and a feigned smile.
And while *marching a mile in your neighbour's boots*
in this instance was not an option,
it did set me to thinking of roots,
and Dutch auctions,
leading to an increased awareness.

To be honest,
I was disappointed they'd all just vanished.
And I was hard pushed to see them,
let alone greet them.
It was as though they'd all been banished,
which only increased their *difference*,
and my curiosity.
Their absence left me slightly frustrated
for now I wondered if it was
something more than '*just the way of them*',
their *otherness*.

Now and again, they'd make an appearance
as if they were on to me,
waiting to put it all to the test.
As sure as a burning effigy
on an Eleventh night bonfire,
a neighbour's eyes would meet mine
for a moment too short for it to be normal.

July puts nationalists asunder,
scattering them over the border
like wildlife before a forest-fire.

Those who opt for the *Wee Six* instead
just can't get the sunshine out of their heads:
Oh, aye, whatever the weather
on any other day of the year,
one thing you can bank on is
The Twelfth will be a scorcher!
Sun splitting the stones
and footpaths hot enough
to fry an egg on,
whether you wanted it or nat!
Believe you me, on The Twelfth,
the Suns of Ulster are all Prods!

The Marching Season stole the thunder
of the season that was in it.
Not surprisingly, summery interests
failed to captivate as murals, long-covered,
received an airing,
their hinged doors devouring all the
strawberries 'n' cream
Wimbledon could ever offer.
For some, it was all a question of maths:
1690 went into 1979, 1987, or even 1999
quite easily, carrying everything forward.
Others did their sums in another way,

having already received quite different results
in history, geography, and Christian Doctrine.
So, who's to know the why, what and hows of it?

Father and son on another expedition,
this time to a town called Scarva,
where, year in, year out,
the victors wore impressive rigouts
and used giant horses to re-enact
the 'slaying' of King James by King Billy.
James died elsewhere some years later
– this was The Sham Fight at Scarva.

I remember having it explained to me right,
and just to make sure I got all of it clear,
I ran it by my da again:

'So, daddy, that King there wearing the silly big wig
beat that king over there in his silly big wig
at The Battle for the Boyne in 1916?'

'Son, it's the Battle OF not FOR the Boyne,
they weren't fighting for possession of the river
but at the river itself for other reasons,
and it was 1690 not 1916, but aye,
otherwise you have it son!'

'So, Da, what are we?'
'We're Catholics son.'
'So, we lost?'
'Aye, that's right.'

Behind the Lens
and
Between the Lines

The Way of Them

The poem was written to the photograph.

An Orangeman with his back to the camera, 12 July, Killylea, Co. Armagh.

When I told my da I was going to use this one in the book, he shared the caption: 'Do Orangemen have tails? No. Just umbrellas!'

I hadn't noticed the umbrella before, but the caption was a fitting embellishment to this photograph.

Not all my mother's family had the same degree of tolerance, but she doesn't know why. We're all informed by our own unique experiences. I really got lucky with my folks in that regard.

Not surprisingly though, tolerance or no, my folks, like me, wouldn't and don't abide the bigots.

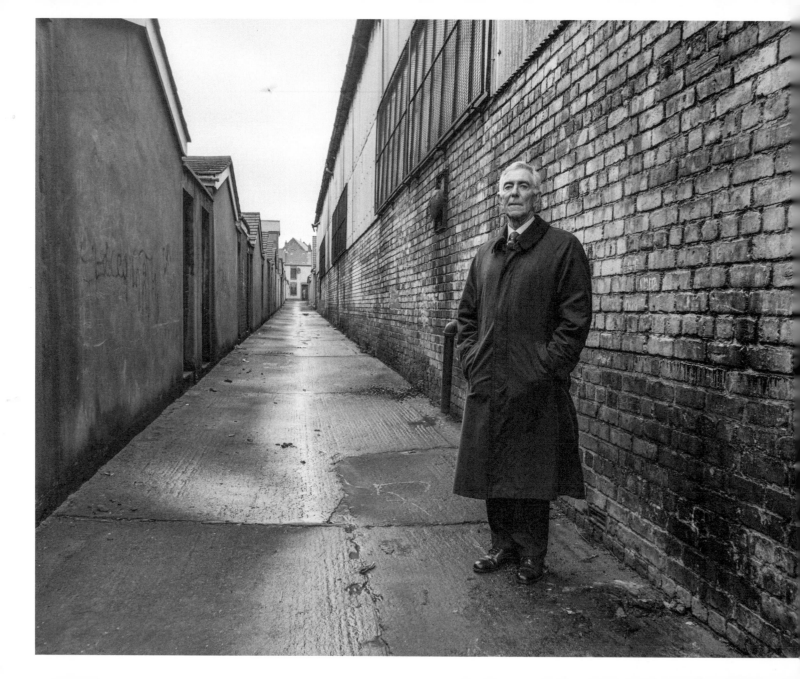

Though I Walk in the Valley …

Houl yer whisht, sit where you are,
I'll bring you another drink down from the bar,
Knock it back, enjoy the craic,
You might wake up dead in the morning.

–Irish folk song

The warm end of the summer-breeze
carried traces of pure release and glee
in sound-waves from nearby enclaves
of a people who'd never known
any shape of peace,
and those who wouldn't dare dream it.

Things were far from festive though
on the Shankill road,
where people were talking
of sell-outs and treachery.
After Frizzell's bombing and The Butchers' era,
this was a contender for *the* worst night

to be anywhere next or near
this part of Belfast.

It's the wee hours of September 1st 1994:
I'm star-gazing only minutes before
on the roof of the BBC taking in history
where we'd exhausted a lead
we'd earlier received,
a mystery, all of its own making,
about Loyalists switching off
Northern Ireland's big light
as the IRA's ceasefire came in at midnight.

This left our English *Sky* correspondent
in a bit of a pickle:
Now in desperate need of a story,
going off-script,
he pulled an angle out of his hat –
of us three filming the desolate Shankill
from the *top* of the road, to contrast

with the festive Falls and beyond the walls,
at which moment, I hung up my boom-mic
and announced:
*Tonight, of all nights, I wouldn't be caught dead
up the Shankill!*
I might as well have said: *If it wasn't for your lot!*
for all the difference it made.
Sky man was going to get his ceasefire story,
with and not without me, end of.

Daytime name-calling and projectile-dodging
on the Newtownards Road was one thing;
talk of secret deals, sacrifice and Somme,
the odd drunk-swing and an oul' Orange song
were all negotiable in the light of day
but at 1am up the Shankill on *that* particular night was a
different animal altogether,
and not my smartest move … and all of me knew it.
But eager to please my new bosses at basecamp,
I let *Sky* man talk me round somehow.
Instincts ignored,
I was now on autopilot.

Scared stiff and incensed,
I got us moving towards the Shankill,

not a sinner around, for which I was thankful.
There could have been a curfew for all I knew,
the hair-raising absence of a community confused
was truly un-nerving.

White-knuckled, I drove us up the road
to where a *Land Rover* was being stoned
in my peripheral vision at ten-o'clock,
hoping hard *Sky* man wouldn't twig,
but sure … isn't that what he's paid for?
It then just hit me how culturally separate
and alone I was.
An Aussie, an Englishman, and me in a car
sounds like the start of a bad joke,
but this was no joke.

I was driving but every bit the passenger,
the irony being that I'd much more
in common with the folk of the Shankill.

Sky man had just broken his promise,
which came as no surprise,
and I let on not to hear his pleas
to stop and turn around.
My head filled with thoughts of Brown Bears

and Butchers and what I'd said earlier
about being caught dead in the Shankill,
the 'kill' in it pulling me back to an experience
my parents had had in '77 in The Brown Bear bar,
when they put themselves in harm's way,
and how it must run in the family:
UTV had been filming them singing
historical folk songs of Ulster
and promoting their first LP,
and how after the show was over,
my da got to talking to a friendly local,
when a wee man came out of somewhere
and gently squeezing his knee, bent down,
in and personal, to make sure he'd hear:
Bobbie, I think it's time you went home now,
and the 'newspaper man' at the bar,
and how they'd find out a couple of years later
when Nesbitt caught the Butchers,
that the room above the bar had been the lair
their platoon had met in to prepare to ensnare
and cull.
Their leader, the real bogeyman
who haunted our dreams
with his stale tobacco smoke
and patriotic swill-fust hair

may or may not have been there.

The Shankill is seared into our deepest fears,
some of it for good reason.
I know now, it's too late to be anywhere
this late.

I was awoken out of my smoky,
beige-coloured, fear-induced reverie
by *Sky TV* man's harking-on heavily,
so I hung a swift right into the dead-end night
in an effort to quench his appetite
for that elusive sound-bite.

The only thing resembling assurance
came from our Aussie cameraman, Shane,
who said before parting: *Keep 'er runnin' matey!*
It helped a bit, all the same.

I didn't need to be told twice. I said:
You've ten minutes and then I'm gone!
But ten became thirty before too long.
I made to drive off in a last-ditch attempt
to make him see sense,
but he wasn't having any of it.

125

I sat circling a dead-end enclave,
surrounded by murals, tempting fate,
which sent my mind to darker corners
that only the Troubles could offer.

My cramping leg began to tremble
and jumped off the clutch
as a ring tapped the window.
The car stalled just as I mimed *Sky TV*
to yer man in the hoodie.
He gestured at me to roll down my window
as his mate tried the passenger's side.

My heartbeat now flooding my ears and throat,
I tried to map out my great escape.
Thoughts of family snuck in
just as another ring tapped,
but this time more urgently.
Oh, fuck!
I cracked open the window a half-finger
and was assailed by his staccato:
Right! Who are ye and whatdyewant?

And in my best worst Australian accent
I dry-heaved: *Skoi TV, matey!* and pointed

in the direction of the crew,
followed by *Ceasefah, matey! Ye know!*
This seemed to do plenty, for off they went
into the night, right and handy,
and I wasn't about to find out
if they would return, when I roared
at the crew: *Ten seconds I'm gone!*
and revved my way through the Decalogue.

Before us stands
retired Detective Chief Inspector Jimmy Nesbitt,
the man who will be remembered
for catching The Shankill Butchers,
whose murders were known for the manner
in which the victims were shifted
from this place to the other.

As we can see from his countenance,
no amount of accolades have helped him
un-see what he saw so we wouldn't have to;
A man whose being somehow refused
to desensitise him from what he saw,
composure a stranger to him now.

Here, back at a crime-scene too deadly to detail,
his eyes have seen their unfair share.
A north face once upon a fortress,
no longer on guard, no longer buttressed,
his appearance is that of an erstwhile gate-keeper between
private and public worlds,
of secrets much too big to bear,
his face, a physical response to the Troubles.

Half a decade spent with victims pinned on a board,
painstakingly piecing morsels together,
girthed only by walls of silence,
and on other walls,
the next day's rendering of a score,
paint running like blood-spill on the ground,
not yet dry.

It took some courage for Nesbitt to pick this alley to pose in:
I could never imagine it drenched in sunshine.
Somehow, it seems a constant craver,
with gullies that don't discriminate
when it comes to flow.
Blood will do even today
and it has in the past.

His face records the half-lives of the dead,
whose ghosts he tried to make peace with,
and others he carried around in his head,
and won't fully let go of
on this side of the other place.

Behind the Lens
and
Between the Lines

Though I Walk in the Valley …

This piece was triggered by the photograph but drew from lived-through experiences.

Those who know who the 'Shankill Butchers' were will know why this piece is not like the others. I deliberated over whether or not to go there. Those that have read Martin Dillon's book on the Shankill Butchers will fully appreciate my reluctance to open this door.

It's one of my father's most chilling photographs from the period and the more I tried to look away, the more it pulled me in, as if looking for a hearing.

The night I described was one of the loneliest of my life. I had landed a gig with Macmillan Media and was looking forward to a new learning experience. I had been enjoying the energy in Belfast in and around the build-up to the ceasefires, but realised, on that night, that this gig wasn't for me.

It didn't sit well with me that I could get on with, and feel no fear from, Shane the Aussie, and the Sky TV correspondent (Sky Man), but knew that there'd be little if anything to connect me to the locals who resided in the Shankill area. I would like to think we could go some way to fixing that so that no one has to live in fear of the other; that without fear, we could learn more about each other. The first steps are in the knowing.

The events recalled in this poem are all true.

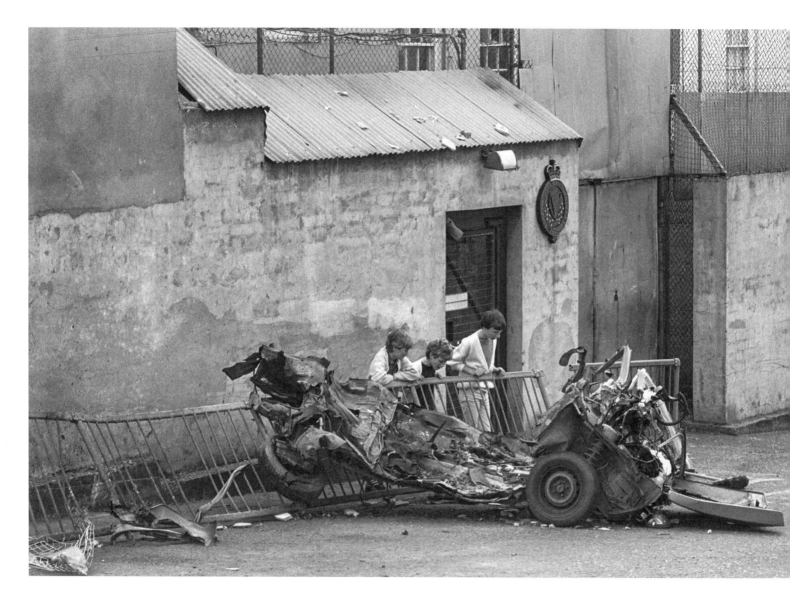

Proxy (Ghost in the Machine)

Then said the Lord unto Moses:
Behold, I will rain bread from heaven for you;
and the people shall go out and gather a certain rate
every day, that I may prove them,
whether they will walk in my law, or no.

–King James Bible

Back before we set gluten free,
back when it was nothing more
than a dirty thought in bakers' dough,
local seers spoke of miracles,
of metal confetti turning into loaves,
teeming down in droves from their heavens.

A curator of blasts might caption this one
'Wreckage before Citadel',
but just eight doors up from us,
this is no half-baked interactive street art;
the installation is already in place,

and like all barracks,
it's a box of sore thumbs.

Post-flash, boom, and spray,
this bread-van is a write-off,
a spectacle let lie, open to inspection.
The only remnants of its true design
are the slices of bread
on the corrugated rooftop.
Toasted and ready to eat,
they will be enumerated and mapped up
by the Dept. of Smithereens,
whose public face is waylaid,
perhaps nursing pints
down at the Horse and Hound bar,
while cheering on the 'Last Suspect'
at Aintree.

Stotious on the shape of things,
lads gather round,

131

leaning into the hurt.
They give the after math a go,
reconstructing the scene,
all the time knowing that
the ghost in the machine
has them in its crosshairs;
hardy boys for a hardy cause, perhaps?

No police to be found about the place.
Have they gone to ground, unfazed?
Truth – a hen's tooth at the best of times –
puts half-heeded rumours to doing their rounds:
Of Peelers inside, wise-cracking no-end,
about finally-claimed barmbrack 'n' farls
left in the bomb-blast's wake,
ending up stuffed into their grateful 'bakes'.

With such Irish whispers a dozen-a-dime,
I'd say the same boys knew right well
how to ring heresy from the hearsayers' bell,
for this was a war as much of the mind,
as any other you were likely to find.

Unbake the moment, go back an hour,
and we find a driver in his van,

all scones, plain, and pan.
Stopped mid-round by familiar voices
made strange by masks,
he protests as new stock is loaded on.
All his deliveries are scrapped save one
– the barracks on Irish Street,
from where he would leg it, if let.

Reassured that all will be grand
if he takes it easy and does what he's told,
he sets out on the longest drive of his life,
perhaps his last.

The world beyond his windscreen
becomes a shibboleth, designed to snag;
The road – all camber, potholes,
and amber lights –
feels like a rug about to be pulled
from under him
by the waves from locals.

Never the same again,
down the pub later that night,
he might be thanked with a pint
and a pat on the back for doing his bit …

... Back before we set gluten free,
back when it was nothing more
than a dirty thought in bakers' dough,
when local seers spoke of miracles,
of metal confetti turning into loaves,
and when they teemed down in droves
from their heavens.

Behind the Lens
and
Between the Lines

Proxy (Ghost in the Machine)

This piece was written to the photograph.

An INLA proxy van bomb on Irish Street, Downpatrick, Co. Down, Northern Ireland. Circa early 1980s.

Quinn's bread van and its driver were commandeered by an INLA unit in Downpatrick for the purposes of priming and driving a proxy bomb to Downpatrick's RUC barracks. For those who aren't familiar with the term 'proxy bomb', it's sometimes referred to as a 'human bomb'. It was a practice that involved coercing people to drive car bombs to British military targets while holding their family captive until the bomb had exploded. In this case, the driver was allowed to exit the vehicle before detonation and no one was injured, at least physically.

This was one of several bombs throughout our years in Irish Street. There were countless 'bomb scares', many of which involved being led down our back yard and garden and into the Irish street car park, where we'd wait with our neighbours in dressing gowns and pyjamas until the suspect device was investigated. It sometimes ended as a 'hoax' (false alarm), or the bomb squad would

be called in to perform a controlled explosion in order to 'make' the device 'safe'. 'Made safe' is still my favourite Troubles collocation.

I used to walk past this eyesore of a police-barracks every day. Lying in bed at night, you'd hear them open the reinforced steel doors to let service vehicles in and out, and the clanging of the bolts being opened and closed.

This was the second time an INLA bomb came too close for comfort (see 'Plan B [Unravelling Night]').

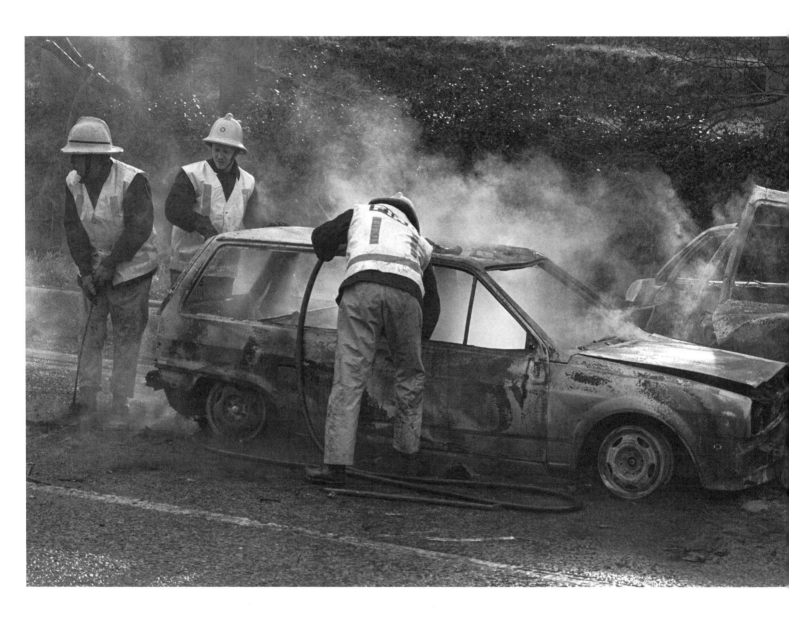

The Ninth Hole

It's Nineteen Eighty-Three,
just six days into October,
and the clocks have stopped
for those who were struck
only a handful of minutes before.

I'm eleven, half-way through the Troubles,
and on my way, like any other night,
to buy fagzmilkinbred
at Dinny Magee's sweet shop,
on up there at the mouth of Meadowlands.

It's just typical:
The chimneyed air is turf-sweet,
with peat-briquettes
blending with the anthracite damp
to produce a heady, balmy mix
of drizzle, the sort that chills your
bones before it even thinks
about dousing your face.

In a world of my own
but not quite away with faeries,
I skirt the corner
and my eyes fill with
ambulance lights and gawkers.

I do a second-take.

I'm torn between the fascination
of this awful scene
and scarpering to alert my mother
and the photographer in my father
of the possible photo op.
But my stalling prevented any of this scene
from making it to film,
for by the time I'd shared the news,
it already was the news.
Nobody would benefit from this night.

So: I'm captured
– chained to the wall of curiosity –
and crank my neck to chance a peek,
getting what I ask for:
A white sheet, blood-stained,
thrown imperfectly,
covering something still.

Next to the ambulance,
a hurt of paramedics shuffles about,
packing up, job done,
after the undoing.

A voice behind my face
tosses *What happened?*
towards the gawkers,
but all I get is:
They're playing a round of golf!
A single grin spreads across
a gallery of faces,
while the jester rests
his arms on the shelf
of his heaving gut.

What? The joke is on me?
Slightly scundered,
I push past into the shop and buy
fags in need of smoking,
and bread born for toasting.

Outside again,
the crowd has filled out some,
with blow-ins fanning the commotion.
And still, that golfing quip
spins and whips,
taut, like cat-gut
around my head.

I head home milk-less,
none-the-wiser, suspecting
I've learned something
without knowing.

History is all about numbers:
That evening, in an office somewhere,
a grim teller flicked two more to the left:
2561, 2562 …

Details followed:
Five years earlier,
one of the slain men had talked a shotgun
out of a man's hand.
The guns on this night, however,
weren't listening.

And the other, a part-timer,
had had his wounds tended to
by those who walked
through the grounds he tended;
he'd been the head-gardener, you see.

It still remains to this day,
a mystery, how in the night's dead air,
there was room, still, for laughter.

I don't remember it,
but my mother never forgot,
telling me to *hold my horses*
until she'd washed the dishes
before giving me the money for
the errands, delaying my saunter
by 10–15 minutes.

And much more, much more,
now lost to me.
But what I *do* recall is that
in the days and weeks that followed,
the town got heavier,
and the air was close,
especially for October.
The town had breathed in,
but had yet to breathe out.

Behind the Lens
and
Between the Lines

The Ninth Hole

The photograph shows a fireman finding his calm in the chaos, practising his golf putt after the crash victims had been taken away to the hospital and the flames of that evening's blaze had been brought to heel.

The events in the poem have always put me in mind of the accompanying photo; in much the same way, the photo has reminded me of the events detailed in the poem, of 6 October 1983, and the human response to shock, trauma and conflict. Is the human ability to function highly while experiencing and witnessing traumatic events *in spite of* said events, or *because of* them?

We're told that with more exposure comes more desensitisation – more numbness – and bad as each event might have been, life went and goes on, at least for the lucky ones.

No matter how we treat the past, what we do know is that bullets won't go back out of bodies and into their guns, in the way the bombs returned to the bellies of the backward flying bombers in Kurt Vonnegut's *Slaughterhouse-Five*. Writing about events such as these isn't easy. The treatment is challenging – you strive to find the right tone, and even though we all own our experiences, you must aim to strike a balance between

telling it as you saw it, and giving the victims and their loved ones their due respect; a duty in itself. I hope that I have been able to do both.

Knowing how lucky I was on that night – not to have arrived that bit earlier – hasn't prevented my mind from putting me through the 'what ifs': *What if you had arrived fifteen minutes earlier? What then?* It's been reported that forty bullets were fired that night, nine hitting their intended targets. Forty adds up to fusillade – a lot of stray bullets, ample room for a ricochet. Indiscriminate violence does not discriminate. *What if you'd seen the gunmen's shots hit their targets in their shoulders and necks? Or watched them fall? What then? What might that have done to your eleven-year-old mind? What if your eyes had met one of the gunmen's eyes?*

Would you have recognised each other, and if so, what then?

In much the same way when I hear the word 'volley' used at Wimbledon, for example, my mind instantly goes to an IRA funeral where 'a volley of shots' was sometimes fired over the coffin. All these years later, the following jigs and jogs the memory: the 1985 mass rally at Belfast's City Hall where Loyalist rioters threw golf balls at the RUC. When I see a photograph of a classmate at his father's funeral and knowing that the killers lay in wait for his return from the golf club. Seeing the 'flag allocators' bicker it out on Twitter, over which flag a County Down golfing champion should play under at the Olympics. It all points back to this night and those words: 'They're playing a round of golf!'

RUC Reserve Constable William Finlay and RUC
Reservist James Ferguson were fatally wounded on 6
October 1983 and the IRA claimed responsibility. It
was exactly fifteen years to the day, that many claim
the Troubles started. Adding salt to sorrow, history
ensured they would have to make do with sharing their
anniversary with another.

The events in this poem happened.

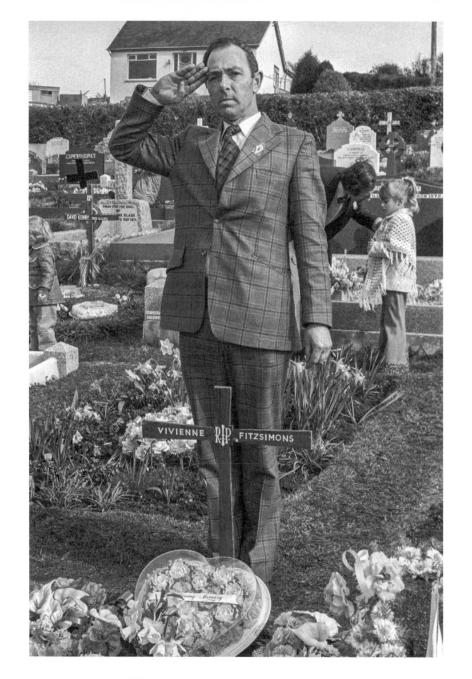

17 (Cause to Grieve)

Here stands a father,
saluting the soldier
in his daughter.
All seventeen years of her.
Sixteen Christmases.
The unthinkable has
stopped with him,
and such doors don't get
un-knocked, un-darkened.

At 17, the only thing I was sure of
was that I wasn't sure of anything;
the only thing I would have died for
was a record deal.

Confronted by the
unnatural order of things,
he tucks her in
for the last time.
Is he suspending grief
with *faux*-composure,

saving his father's face
for a less public place?
Or has death made his heart
as cold and hard as the grave-stone
that surrounds her?
Are there shadows of doubt
to outwit when he meets his sleep
and prays for the gift
of temporary relief?
Must they blacken his slumber,
denying him respite?

At 17, the only thing I was sure of
was that I wasn't sure of anything;
the only thing I would have died for
was a record deal.

Like the kern of old,
she died in the woods,
the bomb, a premature thud
among the branches.

147

No doubt, the dream in her heart
was a nightmare for others.
She died for it, regardless.
Can belief present in life
become disbelief in death?
That's the thing about not being here:
sacrifice is forever crystallised
by a choice, in a moment.

At 17, the only thing I was sure of
was that I wasn't sure of anything;
the only thing I would have died for
was a record deal.

She lived just around the corner from me.
I was but seven months old
when she left home for the last time.
A walk out our front doors
would've given us different views
of the barracks.
I have nothing in the vicinity
of survivor's guilt,

but can't help imagining what life
might have brought her,
had she not been prepared
to die for something.

I determined to live for everything,
and still to this day
have to stop myself
from wondering
what she would make
of the tangibles:
the peace without ease,
the Stormont Dissembly,
interface gates,
street-signs in Irish,
and the relocation of a barracks.

At 17, the only thing I was sure of
was that I wasn't sure of anything;
the only thing I would have died for
was a record deal.

148

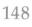
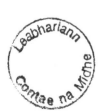

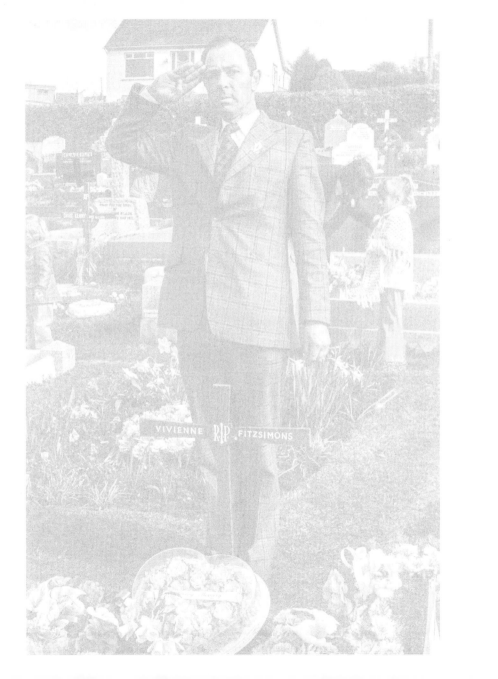

Behind the Lens
and
Between the Lines

17 (Cause to Grieve)

This piece was written to the photograph.

Frank Fitzsimons saluting his daughter, Vivienne, at
her funeral in Downpatrick, February 1973. Vivienne
was killed by a bomb that she and Leo O'Hanlon were
allegedly collecting or moving at Castleward, Co. Down.
Both were members of the IRA.

Photographic Credits

1. Bobbie Hanvey photo courtesy of Patricia Pyne.

2. Steafán Hanvey photo courtesy of Bobbie Hanvey.

3. Rev. Ian Paisley (leader of the DUP, MLA and MEP) posing by the statue of Sir Edward Carson in front of the Stormont building in Belfast, 1985.
 Photographic title: bh007244
 Bobbie Hanvey Photographic Archives (MS2001.039), John J. Burns Library, Boston College.

4. Daniel Rooney's funeral, 1972, Belfast, Northern Ireland.
 Bobbie Hanvey Photographic Archives (MS2001.039), John J. Burns Library, Boston College.

5. Fireman playing with a golf club at the scene of a burnt-out car.
 Photographic title: bh005481
 Bobbie Hanvey Photographic Archives (MS2001.039), John J. Burns Library, Boston College.

6. Brush with the Law, photographs of Traveller children shaking a brush at an RUC officer asleep in the back of a land-rover.

 Photographic title: bh003172

 Bobbie Hanvey Photographic Archives (MS2001.039), John J. Burns Library, Boston College.

7. Man and Child at Divis Flats, Falls Road, Belfast, and men playing cards in front of a republican wall mural.

 Photographic title: bh006198

 Bobbie Hanvey Photographic Archives (MS2001.039), John J. Burns Library, Boston College.

8. Poet, Michael Longley, CBE.

 Bobbie Hanvey Photographic Archives (MS2001.039), John J. Burns Library, Boston College.

9. Seamus Heaney at a turf bog in Bellaghy wearing his father's coat, hat and walking stick and additional shots in the Bellaghy bog.

 Photographic title: bh002800

 Bobbie Hanvey Photographic Archives (MS2001.039), John J. Burns Library, Boston College.

10. RUC officers from Clogher station with Sarah Primrose.

 Photographic title: bh012536

 Bobbie Hanvey Photographic Archives (MS2001.039), John J. Burns Library, Boston College.

11. Official IRA women members of *Cumann na mBan*. Shot taken on Easter Sunday in Scotch Street, Downpatrick.

 Photographic title: bh010930

 Bobbie Hanvey Photographic Archives (MS2001.039), John J. Burns Library, Boston College.

12. Fire (malicious) at the business premises of Hugh J. O'Boyle, building contractor, Downpatrick. Alleged PIRA attack. Night shots of fire and fire-fighters using turntable. Photographic title: bh001288

 Bobbie Hanvey Photographic Archives (MS2001.039), John J. Burns Library, Boston College.

13. PIRA Bomb in Belfast city centre. Shots show one man walking away from the aftermath.

 Photographic title: bh001296

 Bobbie Hanvey Photographic Archives (MS2001.039), John J. Burns Library, Boston College.

14. St Patrick's Day procession, Downpatrick.

 Bobbie Hanvey Photographic Archives (MS2001.039), John J. Burns Library, Boston College.

15. Orangeman on the Twelfth of July.

 Bobbie Hanvey Photographic Archives (MS2001.039), John J. Burns Library, Boston College.

16. INLA attack. Car bomb explodes at Downpatrick RUC station.

 Photographic title: bh001914

 Bobbie Hanvey Photographic Archives (MS2001.039), John J. Burns Library, Boston College.

17. Jimmy Nesbitt, the man who caught the Shankill Butchers.

 Bobbie Hanvey Photographic Archives (MS2001.039), John J. Burns Library, Boston College.

18. Frank Fitzsimons salutes his daughter Vivienne's grave.

 Photographic title: bh010998

 Bobbie Hanvey Photographic Archives (MS2001.039), John J. Burns Library, Boston College.

19. Bomb in the Main Street of Ballynahinch, Co. Down. Shots taken immediately after the bomb blast, almost total destruction of buildings.

 Photographic title: bh001684

 Bobbie Hanvey Photographic Archives (MS2001.039), John J. Burns Library, Boston College.